Zoltan Szabo's
Color-by-Color
Guide to Watercolor

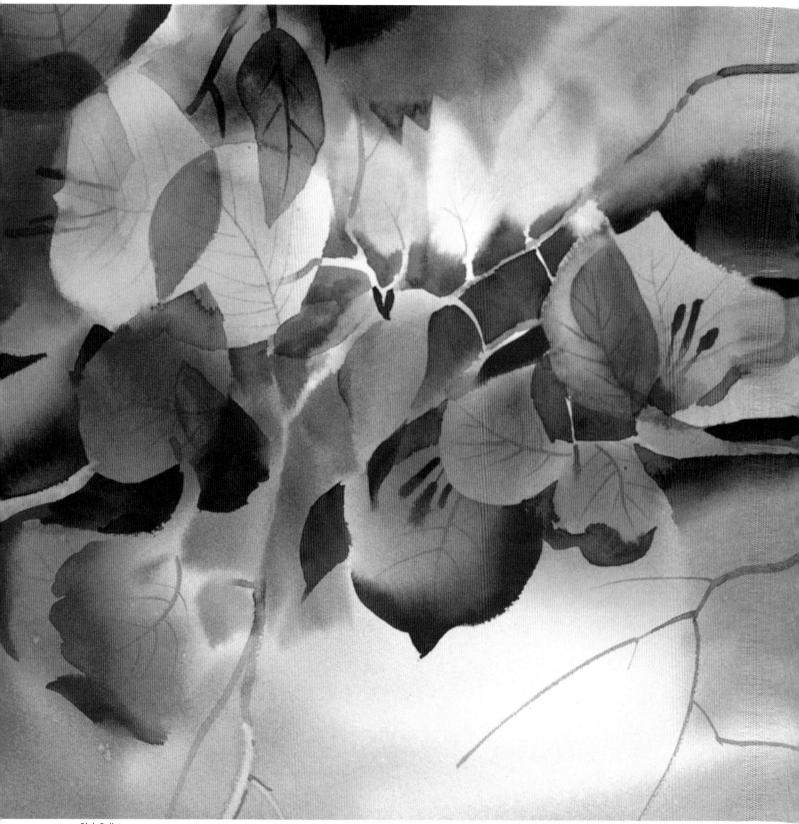

Pink Ballet
Arches 300 lb. cold-pressed,
15″ × 22″ (38cm × 56cm)

Zoltan Szabo's
Color-by-Color
Guide to Watercolor

Zoltan Szabo
SWS, AWA, CAL (Honorary)

NORTH LIGHT BOOKS
CINCINNATI, OHIO

About the Author

Zoltan Szabo was born in Hungary in 1928, where he attended art school before immigrating to Canada in 1949, and then to the United States in 1980. An artist, author and teacher, his watercolor seminars have personally influenced thousands of artists in the U.S., Canada, Europe and even Saudi Arabia.

Szabo is the author of nine books, including two previous North Light titles: *Zoltan Szabo Watercolor Techniques* and *Zoltan Szabo's 70 Favorite Watercolor Techniques*, and is featured in other books such as *Splash 2* and *The Best of Flower Painting* (both published by North Light). Szabo has served as an associate editor of *Decorative Artist's Workbook* magazine for four years, and has been featured in magazines such as *American Artist*, *Art West* and *Southwest Art*. His instructional watercolor videos are internationally distributed.

Szabo is an honorary lifetime member, founding board member and past president of many prestigious artistic societies. Thousands of Szabo's paintings are owned by private collectors throughout the world. His works appear in such noteworthy public collections as the Smithsonian Institution in Washington, DC, the Hungarian National Gallery Archives in Budapest, and in the collections of the prime ministers of Canada and Jamaica. Szabo has over thirty major solo exhibitions to his credit.

Zoltan Szabo Workshops

1220 Glenn Valley Drive
Matthews, NC 28105

336 Forest Trail Drive
Matthews, NC 28105

Zoltan Szabo's Color-by-Color Guide to Watercolor. Copyright © 1998 by Zoltan Szabo. Manufactured in China. All rights reserved. No part of this book may be reproduced in any form or by any electronic or mechanical means including information storage and retrieval systems without permission in writing from the publisher, except by a reviewer, who may quote brief passages in a review. Published by North Light Books, an imprint of F&W Publications, Inc., 1507 Dana Avenue, Cincinnati, Ohio 45207. (800) 289-0963. First paperback edition 2002.

Other fine North Light Books are available at your local bookstore, art supply store or direct from the publisher.

06 05 04 03 02 5 4 3 2 1

Library of Congress has catalogued hardcover edition as follows:

Szabo, Zoltan.
 Zoltan Szabo's color-by-color guide to watercolor / Zoltan Szabo.—1st ed.
 p. cm.
 Includes index.
 ISBN 0-89134-772-0 (hard cover)
 1. Watercolor painting—Technique. 2. Color in art. I. Title.
ND2422.S98 1998
751.42'2—dc21
ISBN 1-58180-297-8 (pbk.: alk. paper)

97-36511
CIP

Edited by Joyce Dolan and Jennifer Long
Production edited by Patrick G. Souhan
Designed by Angela Lennert Wilcox

Dedication

When you write a book, you become an author. To this point the endeavor is the result of an idea and hard work within your control. To publish that material requires someone else who has faith in you and your work. I was one of the fortunate ones to meet an internationally respected, wonderful human being before I wrote my first book. He not only believed that my material was good, but offered to publish it. He proved his faith in a true greenhorn by guiding me through the technical difficulties of the brand new experience of completing a book. My first real break in my professional life is now history. With a grateful heart I want to dedicate this book to the man who single-handedly launched my career, my wonderful friend and mentor, Don Holden.

Acknowledgments

It is a rare privilege to work with exciting and skilled people on any project. This book is no exception.

The first person who comes to mind is Willa McNeill whose friendship, interest and help was a real morale boost during the gray days of writing. Acquisition editor Rachel Wolf planted the idea in my head and made *Zoltan Szabo's Color-by-Color Guide to Watercolor* sound like an enticing challenge. Development editor Joyce Dolan, with her wise and cooperative guidance, created a wonderful atmosphere for work. Content editor Jennifer Long made sure that no detail was overlooked; production editor Patrick Souhan also made invaluable contributions. Finally, my favorite designer, Angela Wilcox, gave these pages the aesthetic look of dynamic and energetic excitement.

I would like to offer my sincere gratitude to these wonderful friends for their hard work, which made this book possible and my job a delight.

Table of Contents

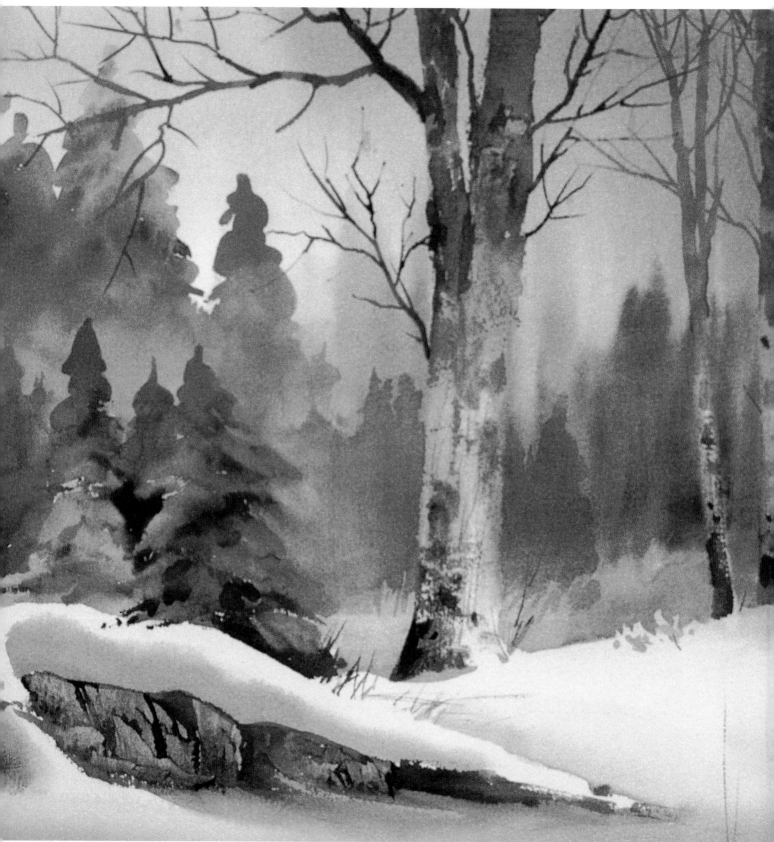

Raggedy Ann
Arches 300 lb. cold-pressed,
15" × 20" (38cm × 51cm)

Introduction

Although there are many fine books published about watercolor behavior, they only partially cover the needs of watercolorists. Beginners, in particular, are shortchanged. My sincere desire is to fill that gap to some extent. These pages include valuable information—from artist to artist—toward that end.

Beginner and early intermediate watercolorists need a clear understanding of the nature of watercolor pigments and the interactions among them. Because of the transparent nature of watercolors, we need to know more about them than just what a hue looks like.

Without light, there is no color. The light, regardless of source, penetrates the thin layer of watercolor on the paper and reflects from the paper's surface back through the pigment layer and into our eyes, showing the true color—just like stained glass does. The nature of each color applied alone or in combination with other pigments will determine if the washes end up as clear and successful as you intend them to be.

These days, countless manufacturers spoil artists with an immense variety of colors. These wonderful choices, however, increase the need for a clear understanding of each brand, because they vary from each other. Different brands may call two similar colors by the same name even though their natures may differ. Accordingly, I have given the specific brand name for each of the colors I demonstrate, as well as brands with reasonably similar characteristics. The characteristics listed for any specific color may not hold true in other brands.

The palette I used for the paintings in this book is made of several brand names of watercolor paints. I selected these colors because they're pleasing to me and prove the compatibility of different watercolor brands. Through your own experimentation, develop a palette of colors that works best for you. Contact your art supplier for information about the wide range of watercolor brands available, and definitely test new colors each time you change brands.

The information in this book is based on my own experiments and years of painting with a conscious awareness of the fickle behavior of my chosen and beloved medium. I had to organize all these idiosyncrasies for the sake of my own sanity, and am delighted to share the information with you. Remember that these are guidelines only, based on my opinion. Your own tests and practice are the ultimate learning tools. I sincerely hope this book sheds light on problems you may have encountered and will broaden your knowledge of watercolor.

How This Book Works

- The book talks only about artist-quality transparent watercolors. Student-quality paints are not covered.

- Each important color family is identified, and each color is dealt with individually.

- A color bar identifies the hue.

- The nature of the color is identified.

- Each color is illustrated with a watercolor painting dominated or strongly influenced by that specific pigment.

My Palette

To complete step-by-step demonstrations in this book, I selected the following colors from my favorite brands to complement my personal needs in watercolor, as well as to demonstrate how compatible different brands can be. I also included the specific color I was demonstrating even if it is not usually on my palette.

All of these colors are artist-quality transparent watercolors, which I squeeze onto my palette and allow to dry. When I'm ready to use them, I replace the water—the only evaporated substance—with my brush. As I mix, I "pollute" only a thin film on top of the dry color. This way I always have a substantial amount of pure color instantly available underneath the mixed layer.

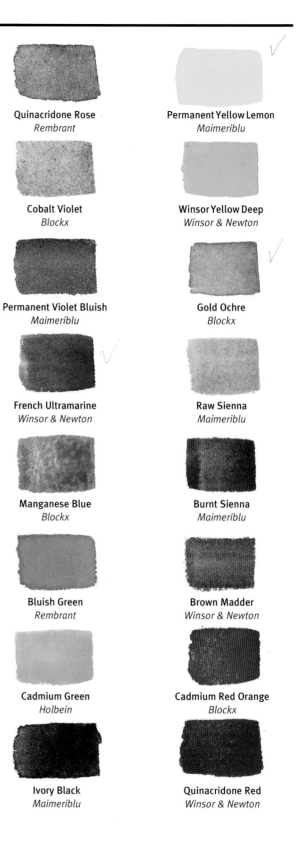

Quinacridone Rose
Rembrant

Permanent Yellow Lemon
Maimeriblu

Cobalt Violet
Blockx

Winsor Yellow Deep
Winsor & Newton

Permanent Violet Bluish
Maimeriblu

Gold Ochre
Blockx

French Ultramarine
Winsor & Newton

Raw Sienna
Maimeriblu

Manganese Blue
Blockx

Burnt Sienna
Maimeriblu

Bluish Green
Rembrant

Brown Madder
Winsor & Newton

Cadmium Green
Holbein

Cadmium Red Orange
Blockx

Ivory Black
Maimeriblu

Quinacridone Red
Winsor & Newton

My Fun Palette

When I use my regular palette, I feel sure of a steady, dependable and predictable result. The additional colors in my fun palette create a surprise effect in my paintings whenever I feel like challenging myself. These colors are all permanent and are made by wonderful and dependable manufacturers who dare to make a few uncommon and excitingly beautiful pigments just for the heck of it. My list of these colors is my compliment to them for their contribution to the magical variety of today's watercolors.

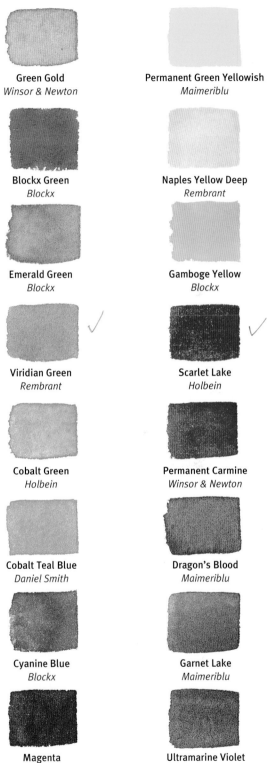

Green Gold
Winsor & Newton

Permanent Green Yellowish
Maimeriblu

Blockx Green
Blockx

Naples Yellow Deep
Rembrant

Emerald Green
Blockx

Gamboge Yellow
Blockx

Viridian Green
Rembrant

Scarlet Lake
Holbein

Cobalt Green
Holbein

Permanent Carmine
Winsor & Newton

Cobalt Teal Blue
Daniel Smith

Dragon's Blood
Maimeriblu

Cyanine Blue
Blockx

Garnet Lake
Maimeriblu

Magenta
Blockx

Ultramarine Violet
Winsor & Newton

Glossary

Analogous colors
Those hues located next to or very close to each other on the spectral color wheel.

Beading
When an intricate negative edge needs defining, tilt the paper 5 to 10 degrees. With a convenient size brush, chase the very wet beading color around the negative edge. The beading, caused by gravity, allows enough time to finish the job without back runs before the paper dries.

Cadmiums
This family of colors (reds, yellows, oranges and greens) tends to be opaque, staining and sedimentary.

Calligraphic
Those shapes that are defined with lines rather than tone.

Charging
Altering the hue in a section of a very wet wash by brushing another wet color into it.

Chroma
The purity or clarity of a hue, without considering its tonal value. Another word for chroma is *intensity*.

Cobalts
Greens, blues, turquoise and violet that hardly cling to the paper. They are nonstaining colors: When dry, they can be removed with a little water and gentle scrubbing.

Complementary colors
Two colors located directly opposite each other on the spectral color wheel.

Controlled back runs
A back run happens when a wash is drying and a fresh volume of water drops into it. As the water spreads, it carries some of the pigment on the surface with it and deposits it in the form of a crude, dark line on the outer perimeter of the unexpected shape, making the colors appear out of control. When this phenomenon is intentionally caused and used as a design element it is called a controlled back run. Sedimentary colors minimize the contrast of the back run's edges; transparent hues increase the contrast.

Curvilinear
This word refers to shapes that are rounded and often repetitive: clouds, treetops, waves and so on. These shapes indicate dynamic, energetic qualities.

Dragging
The hair of the brush is held almost parallel to the paper and pulled on its side while making a brushstroke.

Glazing
A transparent wash quickly applied over another completely dry transparent color without disturbing the first layer of color.

Heavy pigments (sedimentary colors)
Because of their heavy physical weight, when these colors (for example, Cobalt Violet, Manganese Blue) are applied by themselves or mixed with colors of lighter weight well diluted in water, the washes must be painted rapidly to avoid uneven patterns caused by the pigments settling too fast.

Hue
Optically visible quality of a color as we see it (red, yellow, blue and so on).

Intensity
Purity or clarity of a hue, without considering its tonal value. Another word for intensity is *chroma*.

Isolated color systems
When the success of a composition is caused by an effectively placed single color that doesn't appear anywhere else.

Lost-and-found edges
Part of the sharp edge of a wet brushstroke on a dry paper is blended away with a damp (thirsty) brush: While moistening the paper next to the wet color, without lifting the brush, you move into the wet color. The brush soaks up some of the wet color; the remaining amount spreads into the freshly moistened area next to it, blending away into nothingness. By "losing" one edge, the other is "found" as a more important, readable part of the original brushstroke.

Muddy colors
Any combination of colors mixed too thick, or too many colors mixed or glazed together—especially two complementaries, or reflective blues with browns—resulting in a lifeless, dull and generally unpleasant color.

Neutralizing
When a high-chroma color is mixed with its complementary color, with an earth color or with blacks and grays, thereby toning down its intensity.

Phthalos
Phthalo colors tend to be strong stainers and may bronze when heavily applied. It's worth knowing if a phthalo of any brand doesn't stain.

Pollution of mixing water
Sepia, Lamp Black, Payne's Gray and other strong staining colors may pollute the water in your mixing bowl and will dirty up otherwise clean washes. Change water after each use of these colors.

Primary colors
These three colors—primary red, yellow and blue—cannot be mixed out of any combination of other colors.

Quinacridones
Transparent, permanent, intense and usually lightly staining colors.

Rigger brush
A slim brush with a long, soft hair and a good point, especially designed to paint long, uninterrupted lines, such as the rigging on sailboats.

Secondary colors
Hues that can be mixed from two primary colors used in optically equal volume.

Sharp edges
When a shape is painted on dry paper, its edges remain sharp and stay exactly where they are applied.

Slant bristle brush
A thin, flat brush with a slanted edge made from firm, natural bristle.

Spectral color wheel
A color classification system where colors are lined up in the same order as in the spectrum and configured into a circle. Think of a slice cut across a rainbow and bent to form a circle.

Static
A system of shapes where vertical and horizontal edges dominate, indicating stoic, stable qualities.

Tertiary colors
Colors that can be created from one primary and one secondary color mixed in optically equal volume (for example, yellow-green, blue-green).

Thirsty
A brush that is barely moist and is capable of soaking up water better than a dry brush.

Tonal value
The lightness or darkness of a color, without considering its hue and intensity.

Triadic
Any three colors that are located exactly the same distance from each other on the spectral color wheel.

Color Characteristics

Each one of these qualities is independent: The presence of one doesn't mean the automatic inclusion of another. To be absolutely certain of the nature of any pigment, regardless of brand, you must test it for your own complete satisfaction.

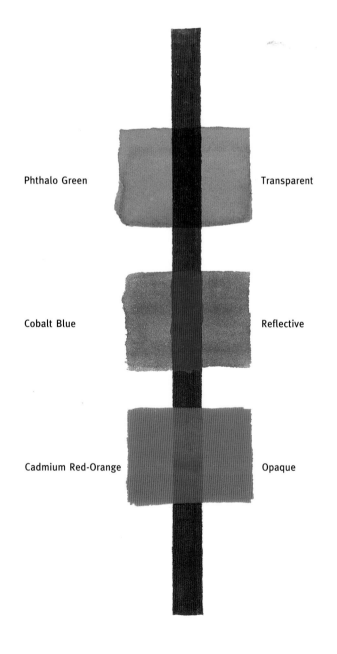

Phthalo Green — Transparent

Cobalt Blue — Reflective

Cadmium Red-Orange — Opaque

True Transparent Colors

Like stained glass, transparent colors allow light to reflect through them from the surface of the paper. These colors are ideal for laying several glazes on top of each other because they do not build up into a thick layer. The more water used in the glazes, the greater the number of luminous coats possible. When used in very dark consistencies, all watercolors, but particularly these pigments, will dry a little lighter than their wet value. However, no matter how dark these pigments end up, they will not go muddy or dull. When diluted in water, these pigments behave similarly to wine or tea—they become one with the water.

Test
When a brushstroke of rich color is painted across a waterproof black line and the color disappears completely over the black bar, the color is transparent.

Semitransparent Colors

Semitransparent pigments are almost as good for glazing as the true transparent hues when used in very light values (diluted by water). To retain a comfortable level of transparency, the maximum number of paint layers must be slightly less than the layers possible for true transparent colors. Whether these colors are painted alone or glazed over other dry layers, they will lose their luminosity earlier than the true transparent pigments.

Test
When a brushstroke of rich color is painted across a waterproof black line and, after drying, it shows a little of its hue over the black bar, it is a semitransparent color.

Opaque Colors

Opaque light hues have a reflective velvety surface when painted in a thick consistency and may cover dark dry colors beneath them. However, the covering strength will diminish from the wet value as the pigments dry. Opaques, when mixed in thick washes, add substance (body) even to other more transparent colors. When too much opaque is used, it can build up into a thick muddy layer and obscure colors beneath. For this reason, opaques are not the best colors for multiple glazing. They will also go muddy if applied with other opaques or with their complementary pigments.

Opaques are at their best when applied in very light washes diluted with lots of water.

Test
When a brushstroke of rich color is painted across a waterproof black line and it covers the black bar substantially, it is an opaque color.

Reflective Colors

Reflective pigments behave somewhat like opaques when used in very heavy mixtures, and may go muddy when overglazed or overmixed. When diluted, they glow like true transparent colors.

Test

When a brushstroke of rich color is painted across a waterproof black line and the hue does not show while wet but becomes recognizable over the black when dry, it is a reflective color.

Sedimentary Colors

When sedimentary colors are used on cold-pressed and rough paper, they fill the cavities of the paper, creating a dotted pattern. On smooth paper, the particles clump together into little islets, allowing tiny water rivulets to form between them. This occurs because the pigments are physically heavy—they sink in water, similar to pebbles. Sedimentary pigments retain their nature even when they are mixed with other colors. Because a grainy texture is the nature of these colors, use them only on subjects that require a textured effect.

Test

Apply a very wet but richly loaded brushstroke of the color in question on white paper. If, after the color has settled, an unmistakable grainy, sandpaper-like texture appears, it is a sedimentary color.

Staining Colors

When glazed, extremely staining colors can tint the paper even through a previously applied dry color. You must be very cautious with these colors.

Staining colors retain their nature even in a mix; however, if they are mixed with nonstaining pigments, the nonstainers will absorb a little of the staining qualities. The result will be less stain on the paper than if the staining color was applied by itself. If two stainers are mixed, their combined hue will prevail in the lifted color, too. If one staining color is applied onto white paper and allowed to dry, and then another staining color is glazed on top of it, the combined hue will appear the same as if they were blended on the palette. If the dry wash is scrubbed off with a wet brush, the first applied color will dominate the resulting light stain.

Test

A rich brushstroke of the color is applied to white paper and allowed to dry. With a very wet brush, the dry color is scrubbed until it looks like liquid paint again and blotted off with a tissue—some colors require repeated scrubbing and blotting. If the color stays in the paper, it is staining. The degree of staining will vary not only from color to color (Phthalo Green and Phthalo Blue), but also between different brands of the same hue (Winsor & Newton Phthalo Blue and Blockx Phthalo Blue).

Nonstaining Colors

These colors are extremely useful when the design demands that a color be removed completely. When these pigments are mixed with semitransparent colors, they absorb some of the stain into themselves, leaving less staining strength to affect the paper.

Test

A rich brushstroke of color is applied to white paper and allowed to dry. With a very wet brush, the dry color is scrubbed to look like liquid paint again and blotted off with a tissue. If the color comes off, exposing white paper, the pigment is a nonstaining variety.

Permanent Colors

Mixing permanent and fugitive colors does not ensure permanence. The fugitive portion remains fugitive; i.e., a fugitive red and a permanent blue make a violet. After time, the red fades and you are left with blue only.

Test

An international organization tests and grades every color before it is allowed to enter the market. The organization's neutrality and the power given to it guarantee the truthfulness of the manufacturer's declaration of permanency.

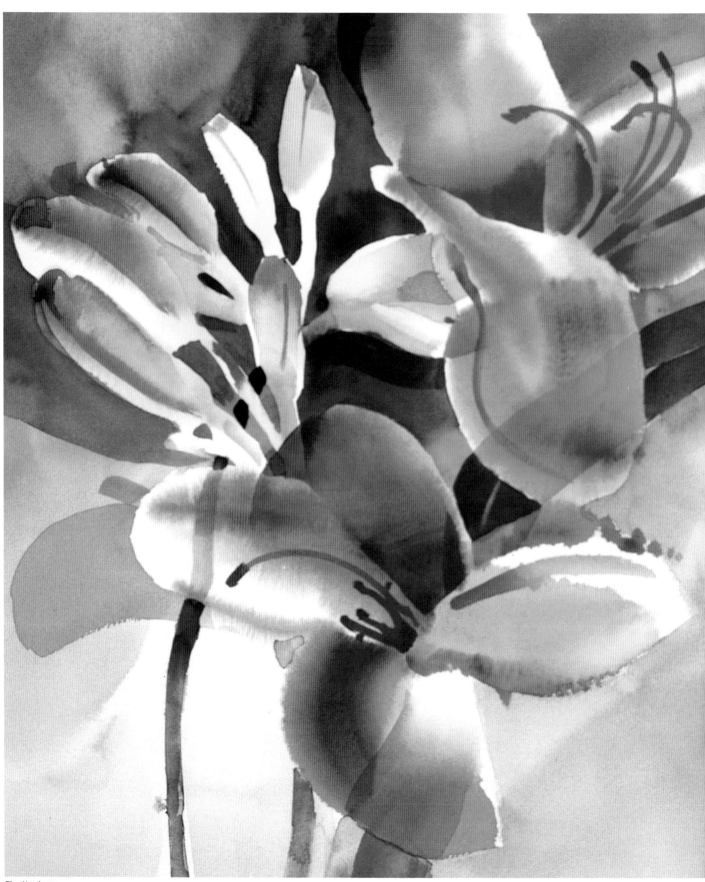

The Newborn
Arches 300 lb. cold-pressed,
15" × 20" (38cm × 51cm)

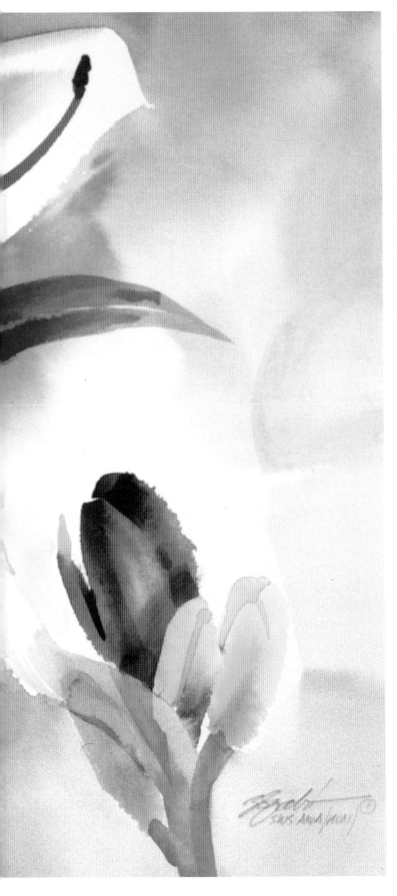

Reds

Reds are the warmest of all colors, representing fire, energy, excitement and life forces. One of the most recognizable life-supporting substances is blood, which makes a rosy cheek blush with its hint of red—a sign of good health. A large number of flowers, with their irresistible power of attraction to insects as well as to humans, come in different shades of reds.

> " *Color has taken hold of me; no longer do I have to chase after it. I know that it has hold of me forever. That is the significance of this blessed moment. Color and I are one. I am a painter.*"
>
> —Paul Klee (1879–1940), on his return from Tunis, 1914

Cadmium Red Light *Maimeriblu*

All cadmiums are brilliant yellowish reds. In spite of their intensity in full strength, their tonal values count only as midrange. They are capable of covering a dark dry wash if glazed fast and in heavy consistency. They perform best when used alone in diluted washes or mixed with analogous hues.

Their nature is compatible with fleshtones, brilliant sunsets, fire, flowers or other high-intensity subjects.

◆ Characteristics
- Lightly staining
- Opaque
- Permanent
- Reflective
- Sedimentary

❖ Colors with reasonably similar characteristics
Cadmium reds of most other brands (Daniel Smith, Holbein, Rembrant, Windsor & Newton), Winsor & Newton Winsor red, Daniel Smith Organic Vermilion, Rembrant Permanent Reds, Holbein Vermilion

■ Complementary color
Blue green

▲ Watch out for . . .
Mixed with their complementary colors, Cadmium Reds can mud up and lose intensity as they neutralize.

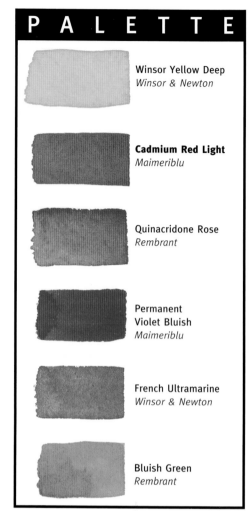

PALETTE

Winsor Yellow Deep
Winsor & Newton

Cadmium Red Light
Maimeriblu

Quinacridone Rose
Rembrant

**Permanent
Violet Bluish**
Maimeriblu

French Ultramarine
Winsor & Newton

Bluish Green
Rembrant

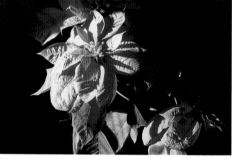

REFERENCE PHOTO

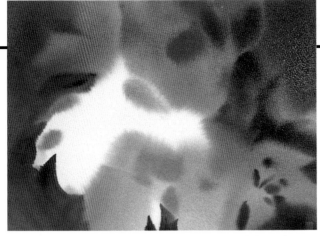

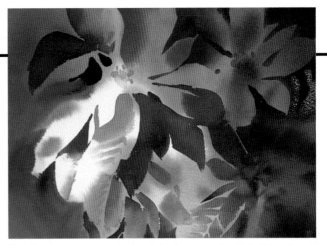

1 I wet my paper thoroughly until the surface stayed shiny, then established the warm, cool and white shapes with a 2-inch soft slant brush. I charged the dominant colors with other colors while the washes were still dripping wet. The cool background shape on the left was painted with a well-diluted wash of Bluish Green and Permanent Violet.

2 After the paper was dry, I switched to a smaller ¾-inch brush and painted the repetitive shapes of the petals. For the lighter reds, I used both Cadmium and Quinacridone Rose. For the more shaded shapes, I added Permanent Violet to my reds and used thicker paint. I was careful to leave a mix of sharp and soft edges.

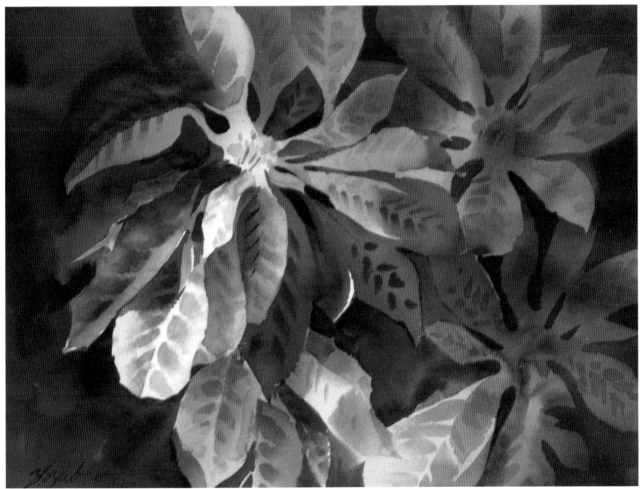

3 I textured the petals with negative veins and added details such as the yellow centers. I also darkened parts of the background—particularly next to the lightest sections of the flower—with a rich mix of Bluish Green, Permanent Violet and a touch of Cadmium Red Light, applied quickly so the wet wash stayed on top of the dry color.

Poinsettias
Arches 300 lb. cold-pressed,
11″ × 15″ (28cm × 38cm)

Scarlet Lake _Holbein_

Scarlet Lake is a strongly staining, intense pinkish red of medium tonal value. It dries back from wet brilliance to a lighter value and paler intensity— use an extra amount of pigment in your brush if you wish to achieve a strong color with one wash. It glazes successfully and mixes equally well with any color. Even when applied with nonstaining colors, its staining strength is strong enough to guarantee its color dominance after lifting.

Ideal for washes representing bright sunsets, colorful garments and flowers.

◆ Characteristics
- Permanent
- Staining
- True transparent

❖ Colors with reasonably similar characteristics
Rembrant Permanent Red Medium, Daniel Smith Pyrol Scarlet, Winsor & Newton Scarlet Lake

■ Complementary color
Green

▲ Watch out for . . .
Scarlet Lake is not very successful when used in fleshtones.

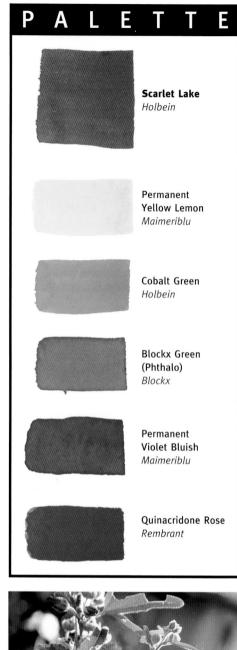

PALETTE

Scarlet Lake
Holbein

Permanent Yellow Lemon
Maimeriblu

Cobalt Green
Holbein

Blockx Green (Phthalo)
Blockx

Permanent Violet Bluish
Maimeriblu

Quinacridone Rose
Rembrant

REFERENCE PHOTO

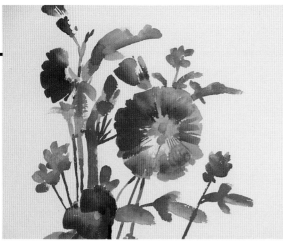

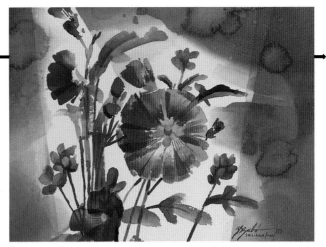

1 My idea was to encourage the white paper to form an abstract halo around the flowers, blending into an abstract darker background. Starting on dry paper with my ¾-inch aquarelle brush, I roughed in the flowers and buds using light brushstrokes of Scarlet Lake and Quinacridone Rose. I linked these with stems and leaves dominated by Cobalt Green. For the petals of the largest flower, I started at the outside edge and painted quick brushstrokes toward the center with a swooping motion. The star-shaped white center of the flower ended up with a dry-brush edge.

2 By half filling my 2-inch flat soft slant brush at the long-hair end with a rich mix of Permanent Violet, a little Cobalt Green and some Scarlet Lake, I was able to blend the inside of the background shape as I painted it. As soon as this wash lost its shine, but before it dried, I dropped clear water into it and created a few abstract back runs to animate the background a little.

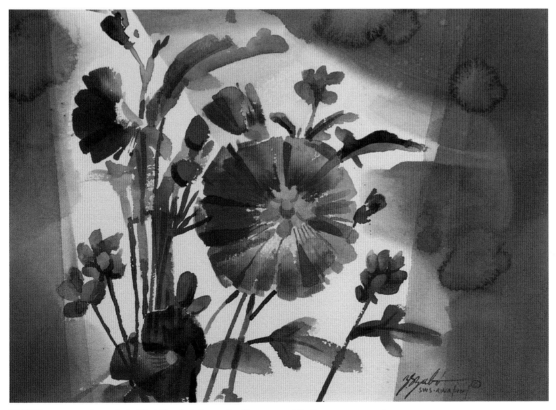

3 With my no. 3 rigger I clarified the details on the flowers and their stems. I also added some really dark red accents to the flowers using Scarlet Lake, Permanent Violet and Quinacridone Rose. Because the background seemed far too monotonous, I applied vertical glazes to unify and strengthen the composition. I chose opaque Cobalt Green diluted into light washes to minimize its opacity. These light washes created a light-reflective effect, tying the sketch together.

Spring's Smile
Arches 300 lb. cold-pressed, 11″×15″ (28cm×38cm)

Winsor Red *Winsor & Newton*

An intense color of medium tonal value, Winsor Red is suitable to influence any mix because of its purity. Its staining is so strong that it will stain not only the paper but other colors in a mixed wash. If used in a glaze, it will stain the color underneath, reducing the brilliance of both colors.

This color is most useful when extreme intensity is required, such as in background mixes, flowers and garments.

◆ Characteristics
- Opaque
- Permanent
- Reflective
- Semitransparent
- Staining

❖ Colors with reasonably similar characteristics
Daniel Smith Permanent Red, Rembrant Permanent Red Light, Holbein Vermilion, Maimeriblu Sandal Red

■ Complementary color
Green

▲ Watch out for . . .
Winsor Red isn't a good ingredient for deep, intense darks because it's a little too opaque. It's also too staining for fleshtones.

PALETTE

Winsor Red
Winsor & Newton

Dragon's Blood
Maimeriblu

Gamboge Yellow
Blockx

Blockx Green (Phthalo)
Blockx

Cobalt Teal Blue
Daniel Smith

Permanent Violet Bluish
Maimeriblu

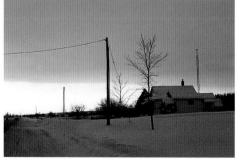

REFERENCE PHOTO

1 I chose rich colors to turn a weak reference photo into a dramatic scene. After wetting the paper with a 2-inch soft slant brush, I painted the sunlit sky beneath the dark clouds using Winsor Red and Gamboge Yellow. Above this brilliant warm color I painted a rich tone of violet derived from Permanent Violet Bluish, Winsor Red and a little Blockx Green. I kept strengthening this wash with more paint until it looked right. Then I charged a wash of Winsor Red into the wet dark violet, replacing the violet with the glowing red. While the sky was still damp, I blotted out the roof shape with a tissue. I also painted a slightly lighter version of the sky color over the foreground.

2 While the background was still damp, I dropped in the backlit edges of the trees using Winsor Red in a 1½-inch slant bristle brush. I added Permanent Violet and Blockx Green to this wet wash to define the darkest values on the shrubs as well as the lone pine's foliage. While this wash was still moist, I painted the snowy roof of the house with the same color used in the foreground. I also charged in the orangy shrubs in front of the house and redefined the base with very dark color, indicating stubby grass in the snow. A bristle brush is wonderful for this technique on dry paper. I applied the same dark color around the reflecting orange window.

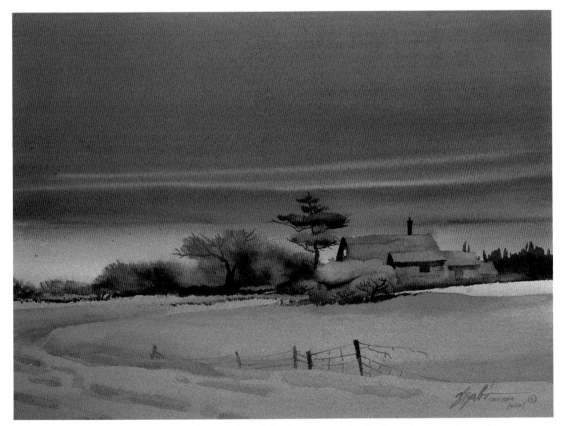

3 With a small no. 3 rigger, I painted in the branches of the distant trees, the shrubs and the details on the house. I modeled the snow with the same color glazes as the base wash, but in darker value. I used my ¾-inch aquarelle brush to paint the snow shapes, and lost (blended) the top edges with a thirsty 1-inch slant bristle brush. Last, I tucked the broken fence portion into the snowdrifts with a no. 3 rigger.

Going to Sleep
Arches 300 lb. cold-pressed,
11″ × 15″ (28cm × 38cm)
Collection of George and
Mary Sculley.

Brown Madder *Winsor & Newton*

Brown Madder is a hue of medium intensity and of low tonal value. It falls between the reds and the browns. Its luminous dark glow is beautiful by itself and is useful in warming other colors. If mixed with blues in darker washes, Brown Madder does not go muddy like Burnt Sienna.

This is a very effective color for painting rocks, deep-lake water and deep-autumn foliage, and for darkening fleshtones.

◆ **Characteristics**
- Permanent
- Staining
- True transparent

❖ **Colors with reasonably similar characteristics**
Holbein Light Red, Rembrant Permanent Madder Lake Brown, Daniel Smith Deep Scarlet, Maimeriblu Avignon Orange.

■ **Complementary color**
Blue green

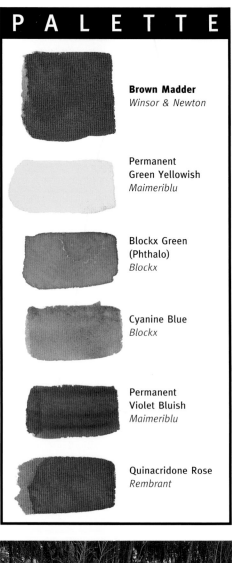

PALETTE

Brown Madder
Winsor & Newton

Permanent
Green Yellowish
Maimeriblu

Blockx Green
(Phthalo)
Blockx

Cyanine Blue
Blockx

Permanent
Violet Bluish
Maimeriblu

Quinacridone Rose
Rembrant

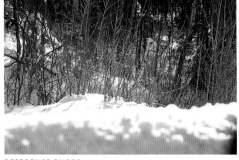

REFERENCE PHOTO

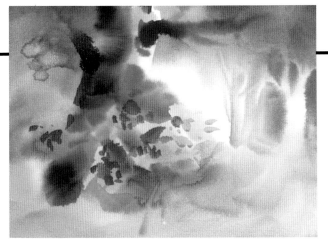

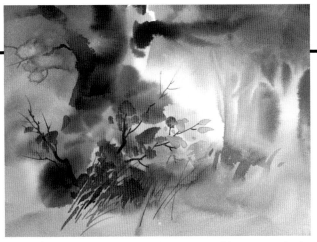

1 I used a 2-inch wide soft slant brush exclusively for this step. Because most of the mood of this watercolor had to be established on wet paper, I saturated the paper with water until the surface remained shiny. I painted the warm colors with rich loads of Brown Madder, Quinacridone Rose and Permanent Green Yellowish, mixed on the paper to gain time. For contrast, I left some untouched white right behind the top of the large tree. I charged several colors into the tree trunk, making it dark but colorful.

2 After the paper dried, I defined the anatomy of the autumn shrubs by painting a few leaves and branches. I merely hinted at their shapes, carefully protecting the integrity of the soft edge. I used a ¾-inch flat aquarelle brush and a no. 3 rigger.

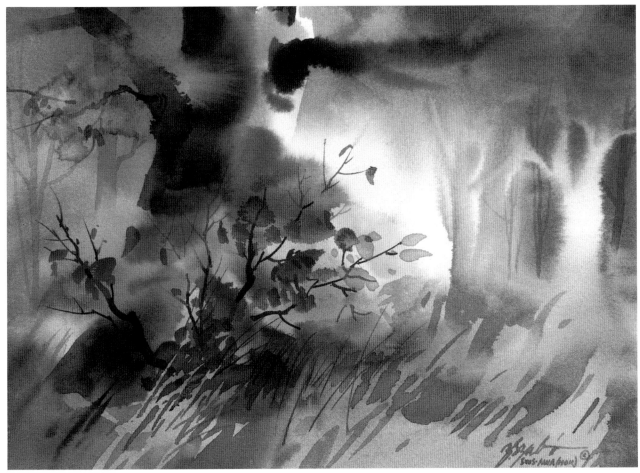

3 Using the same brushes, I turned my attention to the foreground. I added the grassy clutter to anchor the dark tree into the soft ground color. Brown Madder and Permanent Green Yellowish gave me the rich golden colors. Wherever neutral hues were necessary, I added Permanent Violet Bluish—a complementary of yellow.

Captive Light
Arches 300 lb. cold-pressed, 11″ × 15″ (28cm × 38cm)
Collection of Edie S. Griffin.

Permanent Alizarin *Winsor & Newton*

This color replaces the old Alizarin Crimsons; it is similar to the old color but more lightfast. It's a dark, intense red with a dark tonal value. Because of its intensity and extreme transparency, Permanent Alizarin is excellent for dark mixtures. Its mixing purity is good with complementary as well as analogous colors, and it functions equally well alone or mixed. It is also a fine glazing color. Most of the major brands of Alizarins are transparent and staining colors.

Permanent Alizarin is perfect wherever deep reds are needed—such as shading lighter red flowers. It is also useful in after-sunset skies and to make deep violets. If mixed with Phthalo Green, it makes a luminous black.

◆ **Characteristics**
- Permanent
- Staining
- True transparent

❖ **Colors with reasonably similar characteristics**
Winsor & Newton Permanent Carmine, Rembrant Alizarin Crimson, Daniel Smith Carmine, Holbein Rose Madder, Maimeriblu Rose Alizarin Madder

■ **Complementary color**
Blue green

PALETTE

Permanent Alizarin
Winsor & Newton

Burnt Sienna
Maimeriblu

Blockx Green
Blockx

Cyanine Blue
Blockx

Permanent Violet Bluish
Maimeriblu

Naples Yellow Deep
Rembrant

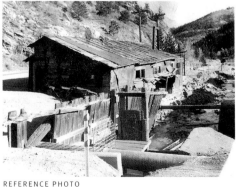

REFERENCE PHOTO

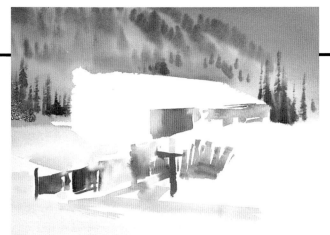

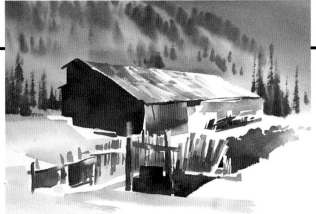

1 Starting with a black-and-white photo, I used my color sense to improve the composition. I filled a 2-inch soft slant brush with a light mix of Blockx Green and Permanent Violet Bluish, and then covered the top half of the paper, avoiding the silhouette of the building. While the wash was still wet, I switched to a 2-inch slant bristle brush and filled it with a dark value of the background color. Holding the brush so that the long-hair end was pointing downward, I dropped in the distant evergreens. For the closer trees, I used more paint and less water in the brush. With my soft slant brush, I dropped in the basic colors on the building and the fence structure, using Permanent Alizarin, Naples Yellow Deep, Permanent Violet Bluish and Cyanine Blue.

2 Next I picked up a 1½-inch flat soft slant brush and painted the dark, shaded side of the structure and the dark parts of the foreground ditch, using Blockx Green and Permanent Alizarin. While these washes were wet, I charged them with Permanent Alizarin, Cyanine Blue and Permanent Violet Bluish and let the mingling colors excite the shapes.

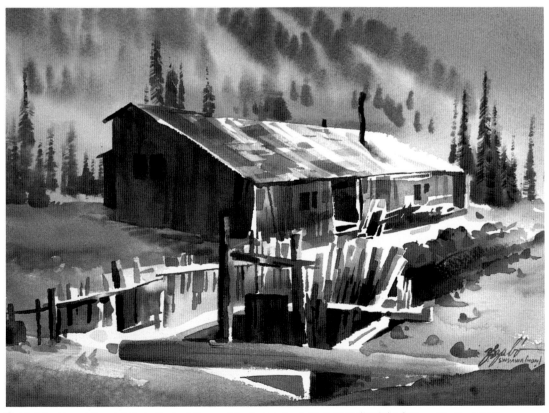

3 I finished by adding details to the building and the fence structure. I neutralized the foreground, but kept it dominated by warm colors. On the roof I spot-glazed several layers of light, warm colors, imitating rusty metal. I carefully protected the white paper next to the strongest sparkling colors and near the dark evergreens at the far end of the building.

The Good Old Days
Arches 300 lb. cold-pressed,
11″ × 15″ (28cm × 38cm)

Quinacridone Rose *Daniel Smith*

This is a bluish-pink color of very high intensity and tonal value. It will not go dark. Its best quality is its compatibility in a wash of any color combination. By itself, it is a brilliant pink; in combination it easily dominates other colors. The hue may vary somewhat between brands, but the basic nature of the color remains the same.

It makes beautiful light violets and oranges, and is useful in fleshtones, skies, flowers or any subject where intense pink is needed.

◆ **Characteristics**
- Lightly staining
- Permanent
- True transparent

❖ **Colors with reasonably similar characteristics**
Rembrant Quinacridone Rose, Winsor & Newton Quinacridone Red

■ **Complementary color**
Yellow green

PALETTE

Quinacridone Rose
Daniel Smith

Permanent Violet Bluish
Maimeriblu

Cobalt Teal Blue
Daniel Smith

Blockx Green (Phthalo)
Blockx

Gold Ochre
Blockx

Burnt Sienna
Maimeriblu

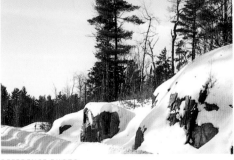

REFERENCE PHOTO

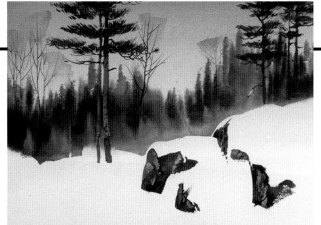

1 After thoroughly wetting my paper, I used a 2-inch soft slant brush to paint the sky and snow with a light wash of Quinacridone Rose, and then darkened the top with a little Permanent Violet Bluish. I then switched to 2-inch slant bristle brush because it works better with dark colors. First I loaded it with Gold Ochre and Quinacridone Rose and painted in the tops of the backlit evergreens. As I advanced to the more shaded evergreens up front, I used Blockx Green with Permanent Violet Bluish and Burnt Sienna to achieve the darkest values. I charged this wet, dark wash with Cobalt Teal Blue to indicate the smaller, frosty evergreens at the base of the trees. While the colors were still damp, I scraped out the large pine trunks with the slanted tip of my aquarelle brush handle.

2 When dry, I painted the dark foliage of the large pines with the same slant bristle brush, mimicking the needle clusters on the pine branches. I linked the foliage to the trunks with a no. 3 rigger, and painted the young trees, the same way. To hint at the fine twigs at their outer edges, I used a 1-inch flat aquarelle brush to paint a light tone of Quinacridone Rose and Burnt Sienna. With a medium-tone wash, I sharpened the bottom edge of the forest and defined the top of the snow in the middle ground. Into the pinkish snow area I painted the sharp silhouettes of the rocks with dark Burnt Sienna and Permanent Violet Bluish, and charged the wet color with Blockx Green, Gold Ochre and Quinacridone Rose. While these shapes were tacky, I scratched out the rocks' light portions with a palette knife.

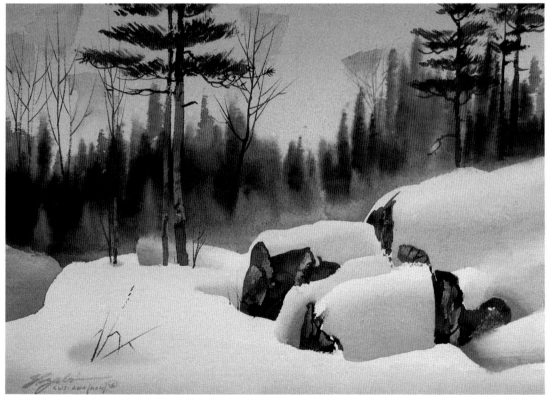

3 With a 1-inch flat aquarelle brush, I modeled the snow to make it appear three dimensional, using mixtures of Cobalt Teal Blue and Permanent Violet Bluish. I painted each section separately so I could lose the top edges before the color dried. I left the bottom edge sharp to define the white snow in front of it.

Blushing Snow
Arches 300 lb. cold-pressed,
11" × 15" (28cm × 38cm)
Collection of Elizabeth J. Conran.

Permanent Rose *Winsor & Newton*

This is a Quinacridone-based, pinkish, high-intensity color. It may be bleached by acids. Its purity makes it ideally suited for any use, whether alone or in a mix. It can be considered as a good primary red.

It is a wonderful charging color and is beautiful in fleshtones, brilliant pink flowers or any intense pink or violet subject.

◆ **Characteristics**
 - Nonstaining
 - Permanent
 - Reflective
 - Semitransparent
 - True transparent

❖ **Colors with reasonably similar characteristics**
Daniel Smith Quinacridone Coral, Winsor & Newton Quinacridone Red, Holbein Permanent Rose, Maimeriblu Quinacridone Rose

■ **Complementary color**
Green

▲ **Watch out for . . .**
Permanent Rose glazes well and leans toward transparency unless used in a very thick consistency—which is not advisable.

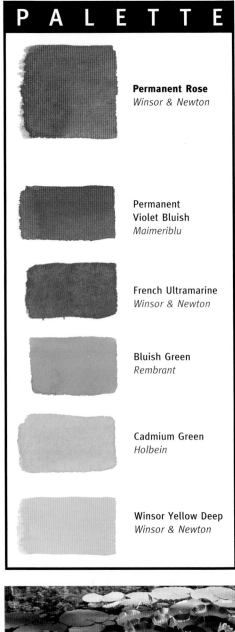

PALETTE

Permanent Rose
Winsor & Newton

Permanent
Violet Bluish
Maimeriblu

French Ultramarine
Winsor & Newton

Bluish Green
Rembrant

Cadmium Green
Holbein

Winsor Yellow Deep
Winsor & Newton

REFERENCE PHOTO

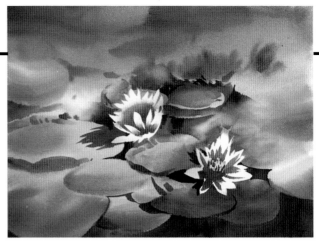

1 The mood of this watercolor was established on a very wet paper, painting this background complement with a 2-inch soft slant brush. I used all the colors on my selected palette, but the Bluish Green, French Ultramarine and Permanent Violet Bluish were the dominant pigments at the top of the paper. Cadmium Green and Winsor Yellow Deep indicate warm light next to the protected white shape, where I plan to place my focal point. The Permanent Rose appears strong because it is isolated at this point. Later, the shapes of distant lilies will occupy this spot.

2 After the paper dried, my next challenge was to define the water lilies as negative shapes with a strong pink interior. To paint around them I used a ¾-inch aquarelle brush filled with a rich mix of Permanent Violet Bluish, Cadmium Green and a little French Ultramarine. As soon as I painted a section of these dark shapes, I lost (blended) the outer edges with a dry 1-inch slant bristle brush, making them softer and less noticeable than the sharp contrasting edges of the lilies. This had to be done while the brushstrokes were still wet and before the appropriate edges had a chance to set in the paper and stain it.

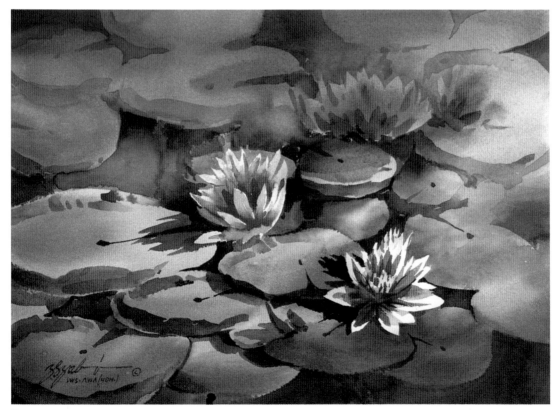

3 Because the sharp edges were too concentrated around the center of interest area, I expanded them carefully to create a more gradual link between the sharp and soft zones. I defined the lily pads with ³/₄-inch aquarelle brush and medium-dark glazes of Bluish Green, Permanent Rose and Cadmium Green in various combinations. The calligraphic details, done with a no. 3 rigger, added the finishing touch.

Water Lilies
Arches 300 lb. cold-pressed, 11″ × 15″ (28cm × 38cm)
Collection of Sokee Parks.

Primary Red (Magenta) *Maimeriblu*

Primary Red is a very transparent, bluish, intense hue. Being a Quinacridone color, it is extremely compatible in any combination with other colors, particularly with analogous hues (reds and blues). Its strength makes it an excellent charging pigment. It holds its wet intensity well even when dry.

Primary Red is a perfect ingredient for beautiful oranges and violets and very useful for after-sunset skies, bright flowers, fleshtones, garments and high-intensity subjects.

◆ **Characteristics**
- Lightly staining
- Permanent
- True transparent

❖ **Colors with reasonably similar characteristics**
Winsor & Newton Quinacridone Red, Daniel Smith Organic Vermilion, Rembrant Quinacridone Rose, Holbein Crimson Lake

■ **Complementary color**
Yellow green

PALETTE

Primary Red (Magenta)
Maimeriblu

Permanent Violet Bluish
Maimeriblu

Cyanine Blue
Blockx

Cobalt Green
Holbein

Blockx Green (Phthalo)
Blockx

Gamboge Yellow
Blockx

REFERENCE PHOTO

1 I borrowed this little cluster of farm buildings from a dull photo. Selecting magenta to dominate the composition, I was ready to create an exciting mood. I started with a 2-inch soft slant brush. On dry paper, I painted a pale Primary Red (Magenta) wash over the top half of the painting, leaving out the shapes of the buildings as negative silhouettes. While this wash was still wet, I charged it with progressively heavier washes of Primary Red (Magenta), Gamboge Yellow, Permanent Violet Bluish and Cobalt Green. Note that I didn't mix these colors into a muddy mess, but allowed each individual color to occupy its own dominant location.

2 Since the top half of the paper was dominated by warm colors and accented with cool hues, I continued with the same brush on the bottom half, reversing the color temperatures. I painted in a medium-dark blue tone with a wash of Cyanine Blue, Blockx Green and Primary Red (Magenta). I charged this wash with hints of Primary Red (Magenta), Gamboge Yellow and Permanent Violet Bluish. I applied quick, angular brushstrokes to indicate shaded rocks. The darkest darks came from Permanent Violet Bluish, Blockx Green and Primary Red (Magenta).

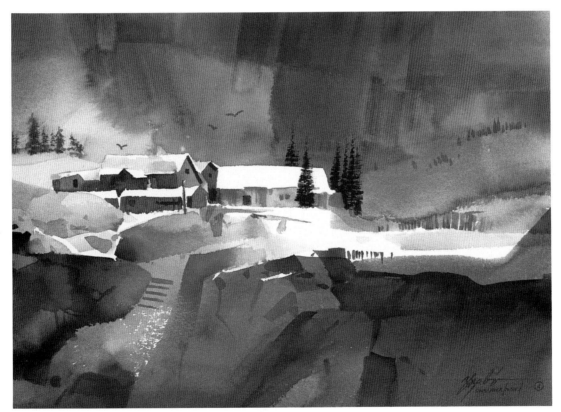

3 When completing the details of the buildings, I made sure to leave plenty of white, but for contrast I painted the walls in medium and dark tones, varying cool and warm dominance. I charged these small, wet washes with lively colors and glazed darker modeling after the first color dried. I accented the buildings with dark windows and doors and then snuggled a few tall trees close to them using a barely moist 2-inch slant bristle brush filled with a dark mix of Blockx Green and Permanent Violet Bluish. Finally I placed a few birds above the buildings.

Winter Mirage
Arches 300 lb. cold-pressed,
11" × 15" (28cm × 38cm)
Collection of the artist.

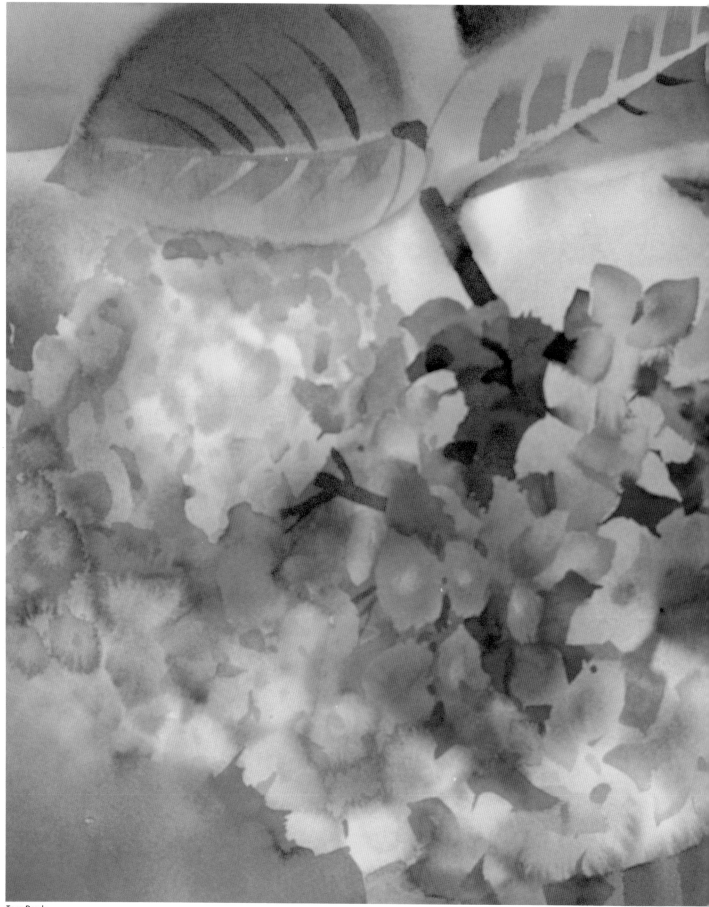

Tom Dewly
Arches 300 lb. cold-pressed, 15"×20" (38cm×51cm)
Collection of Willa McNeill.

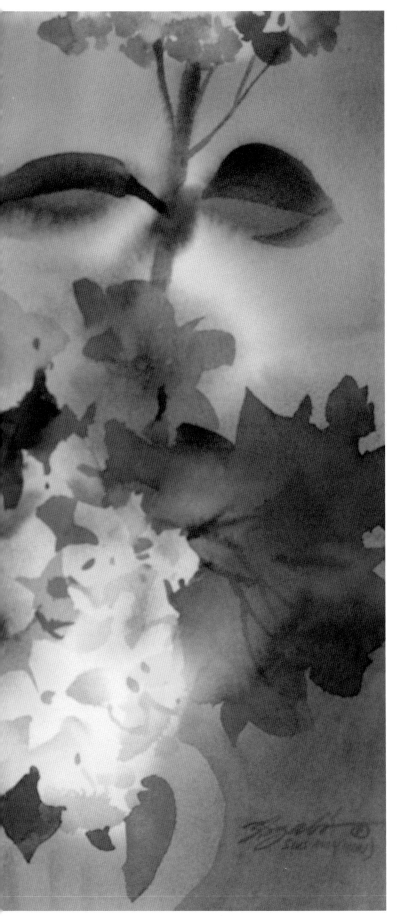

Violets

Violets result from mixtures of two groups of primary colors: reds and blues. They are considered distinct secondary colors on their own. Violets unify the impulsive, energetic reds and the gentle-natured blues. Soothing, somber colors, they represent nobility and a sense of magic and enchantment.

 Art is the unceasing effort to compete with the beauty of flowers—and never succeeding."

—Marc Chagall (1889-1985)

Quinacridone Magenta _Winsor & Newton_

This is an intense color with a medium tonal value. Called a violet because of its bluish hue, it could be considered a bluish red. It will not go dark on its own, but does exert its color influence in dark washes. Because of its purity and transparency, it's ideal for glazing. Its location on the color wheel qualifies it to be used as a primary red.

Quinacridone Magenta mixes wonderful oranges as well as deeper violets, and is very useful in sunsets, flowers, garments, fruits and water reflections.

◆ **Characteristics**
- Lightly staining
- Permanent
- True transparent

❖ **Colors with reasonably similar characteristics**
Daniel Smith Quinacridone Red, Rembrant Permanent Red Violet, Maimeriblu Verzino Violet

■ **Complementary color**
Green

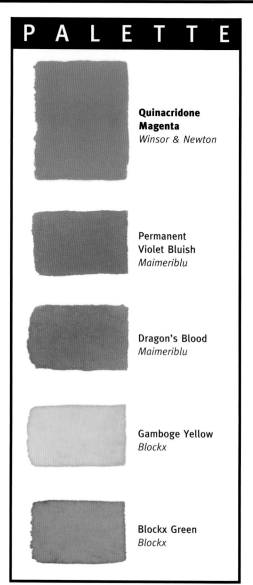

PALETTE

Quinacridone Magenta
Winsor & Newton

Permanent Violet Bluish
Maimeriblu

Dragon's Blood
Maimeriblu

Gamboge Yellow
Blockx

Blockx Green
Blockx

REFERENCE PHOTO

1 I wet the top of the paper, then painted light splashes of Quinacridone Magenta, Gamboge Yellow, Blockx Green and Permanent Violet Bluish with a 2-inch soft slant brush. While the paper was wet, I painted the furthest two islands with a thirsty 1-inch aquarelle brush, using Permanent Violet Bluish, Blockx Green and a bit of Quinacridone Magenta. I made a rocky island appear closer by increasing its size and using a darker concentration of the island colors. I charged the center with Quinacridone Magenta. I did the point of land on the right side, with even darker colors. The rocky texture at the bottom edge was scraped in with the heel of my palette knife.

2 I quickly brushed the shape of the water on the left side using Quinacridone Magenta and Blockx Green. For the sandy shore, I repeated the colors of the sky with a darker tonal value—the warmer, more orangy wash dominates the distance, while the cooler violet takes command in the foreground. Normally, when the light condition is uniform, warm colors tend to advance and cool hues tend to recede. In this case I reversed the color temperature of the two planes and shaded the foreground with cool colors.

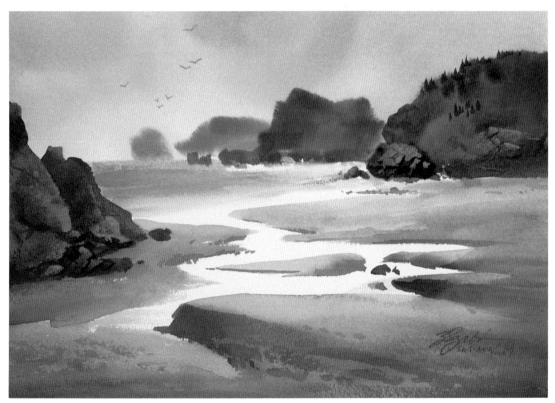

3 I added Blockx Green to the white surf in the distance. Next, I glazed the shore with darker tones using dry brushstrokes, leaving the reflecting puddles white. I further defined the reflecting tidal wash in the sandbar. For the dark rocks on the left, I used a charged application of the same dark colors as in the point of land on the right. I knifed out more light shapes from the damp color to indicate crumbly rocks. I darkened the bottom left portion of the water with Blockx Green and Permanent Violet Bluish, and finished with a few distant birds.

Coastal Reflection
Arches 300 lb. cold-pressed,
11" × 15" (28cm × 38cm)
Collection of Sandi and
Paul Lay.

Cobalt Violet *Blockx*

An extremely permanent pinkish violet with a light tonal value, Cobalt Violet is a gentle color that is easily dominated by other colors in a wash. However, it will quietly sparkle through after the mixed wash has dried, particularly when blended with very transparent colors. Because of its sedimentary nature, it dries grainy and separates from transparent colors on wet paper. It settles at the bottom of the wash immediately upon application; the dissolved transparent pigments spread as long as the wash remains wet.

It is most useful in shadows on snow, birch bark, white rocks and other white surfaces.

◆ **Characteristics**
- Nonstaining
- Permanent
- Reflective
- Sedimentary
- Semitransparent

❖ **Colors with reasonably similar characteristics**
Cobalt Violets of most other brands (Daniel Smith, Holbein, Rembrant and Winsor & Newton)

■ **Complementary color**
Green

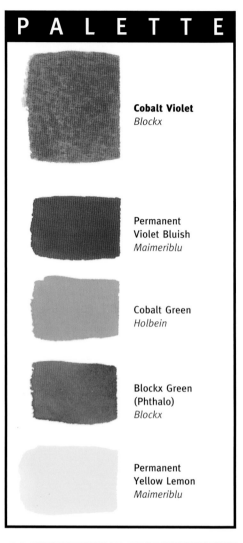

PALETTE

Cobalt Violet
Blockx

Permanent Violet Bluish
Maimeriblu

Cobalt Green
Holbein

Blockx Green (Phthalo)
Blockx

Permanent Yellow Lemon
Maimeriblu

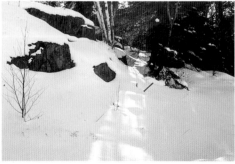

REFERENCE PHOTO

1 On a wet surface, I painted the shaded snowfield using a 2-inch soft slant brush and a rich mix of Cobalt Violet, Blockx Green and small amount of Permanent Violet Bluish. While this color was drying, I painted in the sunny colors of the forest area with a 1-inch aquarelle brush. I charged this wash with Permanent Yellow, Cobalt Violet and Blockx Green—allowing the colors to occupy their own territory but to blend softly where they touched. I waited until the wet surface was losing its shine, and then with the slanted end of an aquarelle brush handle I scraped off the the light tree trunks. Where the Blockx Green stained the paper, the scraped out shapes became light green. Using a no. 3 rigger, I added a few delicate young trees.

2 After my colors were dry, I established the dark, protruding rocks with an aquarelle brush, using a very dark mix of Permanent Violet Bluish, Cobalt Violet and Blockx Green. To be able to knife light shapes off a darker color requires the paint to be applied in a fairly thick consistency, as on the rock shapes in this watercolor. Knowing that by the time I painted on the last rock the first one would be too dry for knifing, I dealt with each shape separately: After I painted each rock, I knifed off the light texture immediately with the heel of my palette knife.

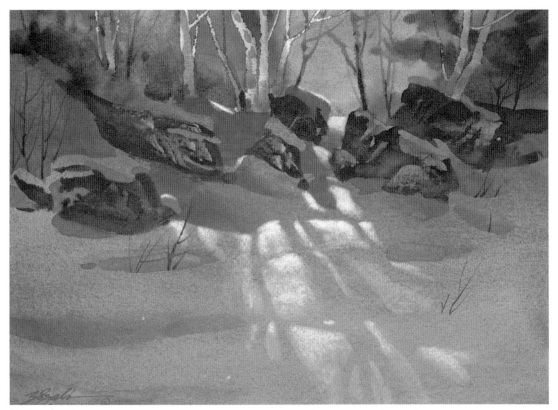

3 After the whole surface was dry, I painted in the dark snow modeling, carefully losing the top edges of each brushstroke without lifting off the lower color. My color combination was the same as the first wash, but the Permanent Violet Bluish was somewhat stronger. When dry, I removed the nonstaining colors to expose the brightly lit white snow, leaving the shadows alone. At last I added the calligraphic shapes of the young trees.

Daring Light
Arches 300 lb. cold-pressed,
11″ × 15″ (28cm × 38cm)

Permanent Violet Bluish _Maimeriblu_

A dark, fairly transparent bluish violet of low tonal value, Permanent Violet glows equally in light and dark washes. It takes only a little of this color to cool dark and warm mixes. Though violets and greens are secondary colors, Permanent Violet mixed with Phthalo Green actually makes a real blue; the extremely high blue content of both colors overwhelms the mixed hue.

Permanent Violet is very effective in late-afternoon cast shadows on snow, and in rocks, stucco and other grainy surfaces.

◆ Characteristics
- Lightly staining
- Permanent
- Semitransparent

❖ Colors with reasonably similar characteristics
Daniel Smith Carbazole Violet, Rembrant Permanent Blue Violet, Winsor & Newton Winsor Violet

■ Complementary color
Lemon yellow

▲ Watch out for . . .
This color seldom occurs by itself in nature. It is most useful when mixed with other colors.

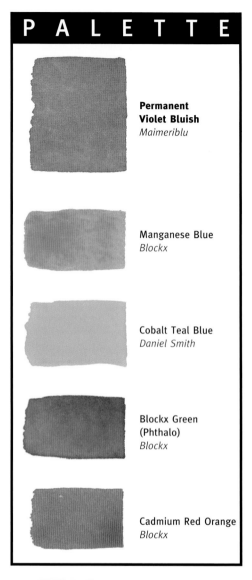

PALETTE

Permanent Violet Bluish
Maimeriblu

Manganese Blue
Blockx

Cobalt Teal Blue
Daniel Smith

Blockx Green (Phthalo)
Blockx

Cadmium Red Orange
Blockx

REFERENCE PHOTO

1 I used juicy mixes of medium-dark colors with my 2-inch soft slant brush on dry paper, actually wetting the paper as I advanced. I varied the dominance of my colors from brushstroke to brushstroke and paid attention to the tonal value changes. To separate the distant slope from the sky, I painted evergreens where they join. With a 1½-inch slant bristle brush held upside down, I dropped in the dark ever-greens, letting them blur a little. At the near edge of the hill, the back-ground color was drier, so the blurring is barely noticeable.

2 Leaving a white spot to emphasize my focal point, I defined the foreground with the same colors and indicated the future rocks with a few wet brushstrokes of Cadmium Red Orange and Permanent Violet Bluish.

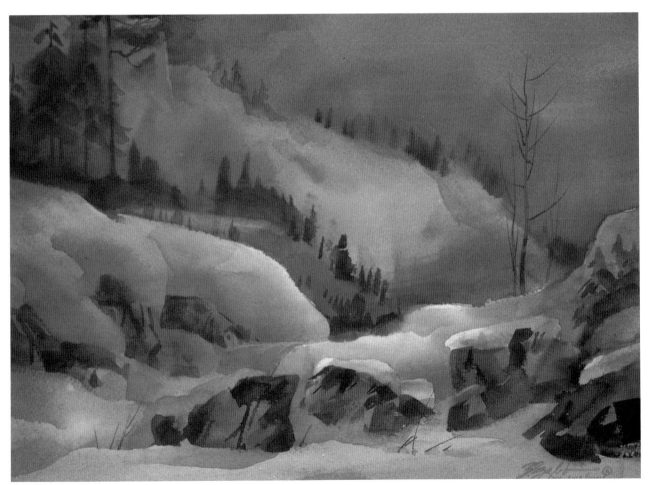

3 After the paper dried again, I defined the dark texture on the snow-covered rocks and increased the value on the shaded, near sides of the snow humps with a 1-inch aquarelle brush. I also gave a little more character to the large evergreens on the left edge. Switching to a no. 3 rigger, I finished with the tree trunks and branches and a few weeds up front.

Blue Mood
Arches 300 lb. cold-pressed, 11″ × 15″ (28cm × 38cm)
Collection of Cindy S. Rogers.

Winsor (Phthalo) Violet
Winsor & Newton

Winsor (Phthalo) Violet is a dark bluish violet of low tonal value. It is a lively contributor to luminous dark washes and can dominate other colors with ease. It can build up and appear opaque when used extremely thickly.

It is a choice color to use in dark, deep water and late-afternoon shadows, or to charge dark cool washes.

◆ Characteristics
- Permanent
- Staining
- True transparent

❖ Colors with reasonably similar characteristics
Daniel Smith Ultramarine Violet, Rembrant Permanent Blue Violet, Maimeriblu Permanent Violet Bluish

■ Complementary color
Warm Yellow

▲ Watch out for . . .
Because the staining strength of this color differs from paper to paper, a little experimentation is advisable. In dark consistency, bronzing (a metallic sheen) can occur; this would indicate that the color was applied far too thickly.

P A L E T T E

Winsor (Phthalo) Violet
Winsor & Newton

Quinacridone Rose
Rembrant

Cobalt Teal Blue
Daniel Smith

Blockx Green
Blockx

Permanent Green Yellowish
Maimeriblu

REFERENCE PHOTO

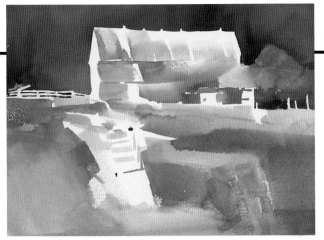

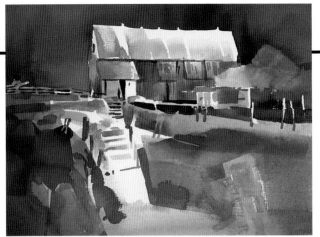

1 I started on dry paper with the background. With a 1-inch aquarelle brush, I painted around the white silhouette of the barn and fence fast enough to let the charged colors blend — particularly the shapes of the tall evergreens. Next, I spot painted the basic character of the barn, allowing strong warm colors to dominate, but leaving plenty of white. To ensure a unified style, I also roughed in the foreground with the same brush and colors, but encouraged the cool greens and violet to dominate and the yellow to accent the washes.

2 After the surface dried, I added some bold details to the barn and to the abstracted foreground. I used plenty of Cobalt Teal Blue mingled with Winsor (Phthalo) Violet and Blockx Green, and even with the Permanent Green Yellowish. Although the white area was reduced, its dominance is still very obvious.

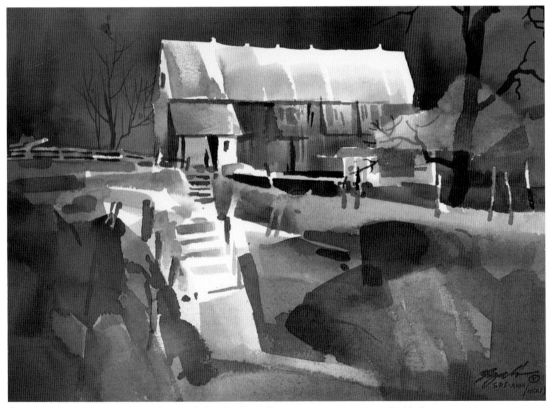

3 The loose abstraction was working well, but further refinements were necessary. I added the tree trunk and branches to the foliage on the right side of the barn, using Blockx Green, Winsor (Phthalo) Violet and a touch of Quinacridone Rose in a heavy consistency outside of the yellow foliage. The trunk and branches inside the yellow areas I did with a lighter application of the same colors, adding yellow to the combination. I did the more delicate tree on the left with a small rigger. I dropped in leaves to indicate that the trees are alive but "asleep." The foreground now seemed too crude, so I made it look more like a rocky hollow by overlapping a few shapes and linking them with lines that read like cracks in the rocks.

When Old Is New
Arches 300 lb. cold-pressed,
11″ × 15″ (28cm × 38cm)
Collection of Helen Adino
Smith.

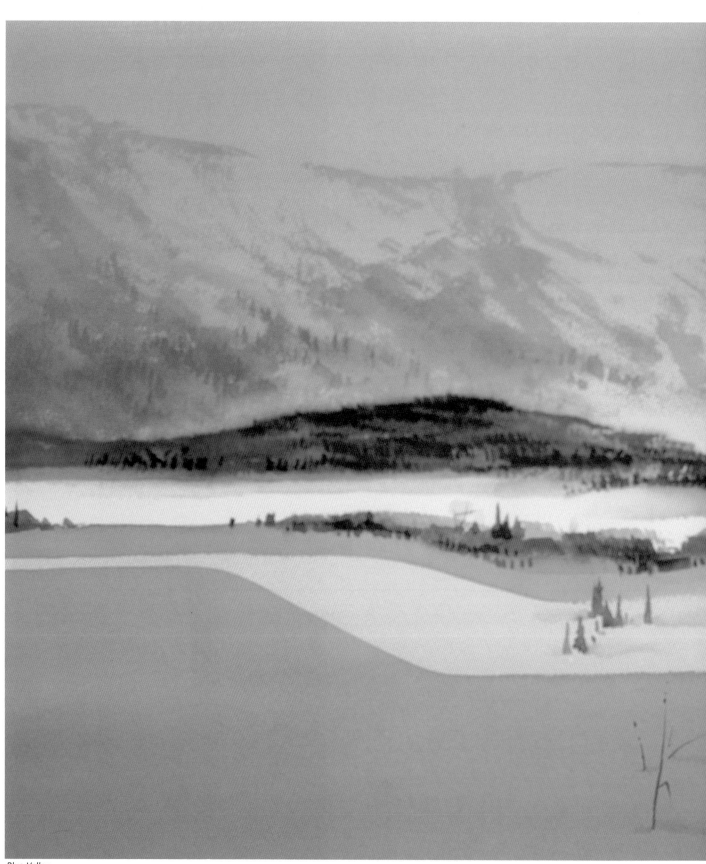

Blue Valley
Lana 300 lb. cold-pressed,
15" × 20" (38cm × 51cm)

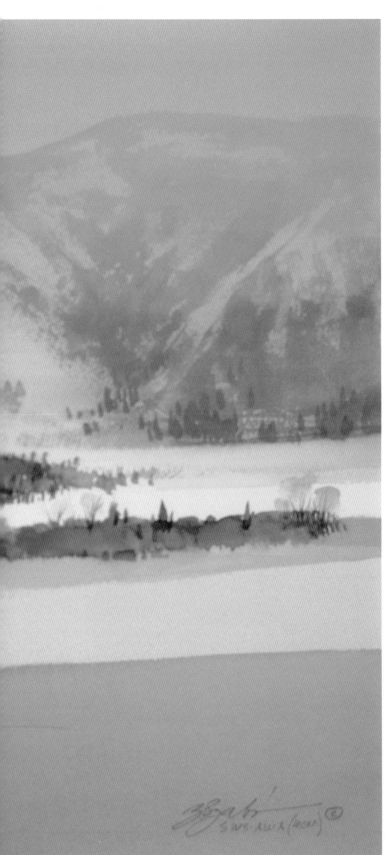

Blues

Reminding us of ice, cold water and air, blue is the coolest color. Blues represent a calm and quiet mood, and are believed to have a pacifying psychological effect on the viewer. They are ideal to suggest tranquility, contentment and lack of tension. In a dominant role, blues offer reassurance.

 The purest and most thoughtful minds are those which love color the most."

—John Ruskin (1819-1900), from *The Stones of Venice*

Winsor Blue (Green Shade) *Winsor & Newton*

This color is an extremely dependable, cool hue of dark tonal value. Winsor Blues are called Phthalos by most other brands. They may be used in a wide range of tonal value without losing intensity or transparency.

Winsor Blues are wonderful base colors for deep blue or stormy skies, dark water, very dark foliage and so on.

◆ Characteristics
- Permanent
- Staining
- True transparent

❖ Colors with reasonably similar characteristics
Holbein, Winsor & Newton or Maimeriblu Prussian Blue, Rembrant Phthalo Blue Red, Maimeriblu Berlin Blue, Maimeriblu Antwerp Blue

■ Complementary color
Warm yellow

▲ Watch out for . . .
Winsor Blues in extremely dark application tend to show a metallic sheen like oil on water (bronzing). This is a sign that the color was applied too thickly to be useful.

PALETTE

Winsor Blue (Green Shade)
Winsor & Newton

Bluish Green
Rembrant

Gold Ochre
Blockx

Permanent Carmine
Winsor & Newton

Ultramarine Violet
Winsor & Newton

REFERENCE PHOTO

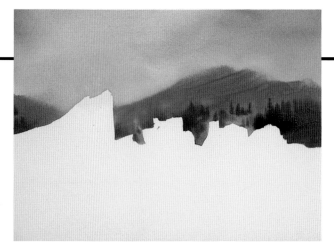

1 I painted the sky and mountains with a 2-inch aquarelle brush. My colors were diluted and distributed to allow the colors to dominate their own areas and also to blend smoothly. I defined the sharp white silhouette of the buttes as a negative shape. I switched to a 1½-inch slant bristle brush and painted the mountain using a thick mixture of all five colors, dominated by the Ultramarine Violet. While this color was wet, I charged it with Gold Ochre at the mountain peaks, replacing the shadow color and making the peaks look sunny.

2 With Permanent Carmine dominating the massive buttes, I used Ultramarine Violet, Gold Ochre and Winsor Blue in a ¾-inch aquarelle brush to show dark layers of the stone. The large Gold Ochre shape at the left side is for foliage of a nearby tree. For the rows of dark junipers, I used a mixture of Winsor Blue, Bluish Green and Ultramarine Violet.

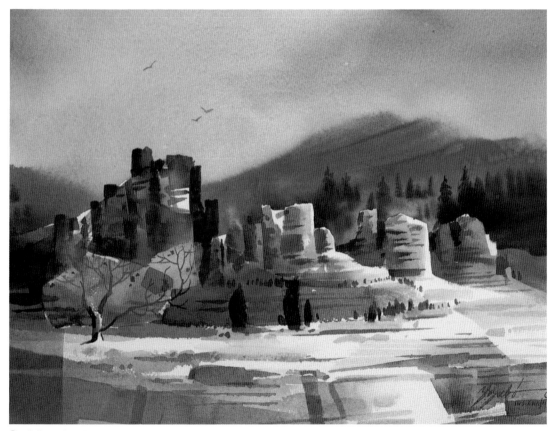

3 I followed with further definition of the buttes and the tops of the tall trees behind them, and particularly the bright tree on the left. The calligraphic branches of this tree are the result of delicate lines painted with a small no. 3 rigger. The abstracted foreground shapes are dominated by rhythmical, mostly horizontal areas of reddish color. I felt that stronger verticals were necessary to counter the overwhelming horizontal dominance, so I glazed a few pale and cool angular shadow shapes, which also enhanced the strength of the white.

Desert Winter
Arches 300 lb. cold-pressed,
11″ × 15″ (28cm × 38cm)
Collection of Kimberly
McNeill.

French Ultramarine *Daniel Smith*

Ultramarines used to be made from the semiprecious stone lapis lazuli. French Ultramarine is a synthetically created color with qualities similar to the natural ultramarine—the workhorse color for most watercolorists. This color is a semi-opaque pigment of medium tonal value. Daniel Smith's French Ultramarine stains lightly, but the staining quality varies in other brands. Because of its opaque and reflective natures, it is most useful when diluted with water.

Ultramarines make beautiful, soft snow modeling when mixed lightly with Burnt Sienna, and enrich sky color when added gently.

◆ Characteristics
- Lightly staining
- Opaque
- Permanent
- Reflective
- Sedimentary
- Semitransparent

❖ Colors with reasonably similar characteristics
Winsor & Newton Permanent Blue and Ultramarine Blues of most other brands (Rembrant, Holbein and Maimeriblu)

■ Complementary color
Yellow orange

▲ Watch out for ...
Ultramarines, including French Ultramarine, don't make good darks. When mixed with earth colors in thick consistency, the result is lifeless, tired and muddy colors.

PALETTE

French Ultramarine
Daniel Smith

Permanent
Violet Bluish
Maimeriblu

Cobalt Green
Holbein

Burnt Sienna
Maimeriblu

Permanent
Yellow Lemon
Maimeriblu

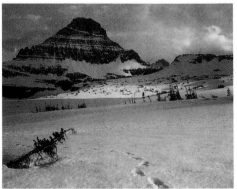

REFERENCE PHOTO

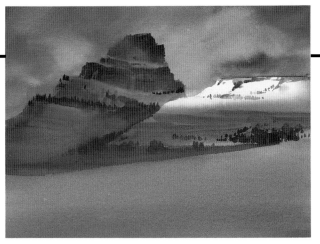

1 Speed was very important for the start of this watercolor. Although French Ultramarine dominated these rapidly painted washes, all the other colors were gently charged into the wet paint for color variation. I carefully painted around the white shape with a sharp edge at the top and soft (lost) edge at the bottom.

2 To make the white shape look like a snow-covered and sunlit mesa, I painted the exposed rocks with a small rigger, using Burnt Sienna and Permanent Yellow Lemon. I added a little Cobalt Green to the distant evergreens in the same area. With Burnt Sienna and Permanent Violet Bluish, I glazed on the rocky layers of the dark peak. To indicate rows of trees in the shaded sections, I used the corner of a ¾-inch aquarelle brush. I also sharpened the edge of the dark color between the middle-ground valley and the snowy hill in the foreground.

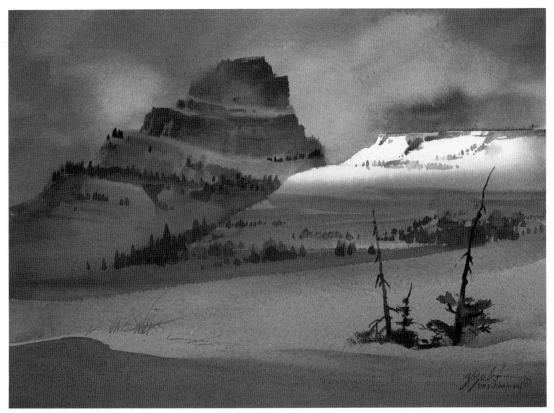

3 To prevent monotony in the foreground, I painted the large drift and the blue weeds at the bottom left corner with French Ultramarine, Permanent Violet Bluish and Cobalt Green. I did the sharper, more distant trees with the same colors but in darker value. The two Alpine firs sticking out of the snow in the foreground add high-elevation consistency and a calligraphic touch that leads to the center of interest. I used all the colors except yellow to paint these dark trees—the warm Burnt Sienna accent makes them feel close.

Inner Space
Arches 300 lb. cold-pressed,
11″ × 15″ (28cm × 38cm)
Collection of the Mossy
Brake Art Gallery.

Cobalt Blue *Rembrant*

Like all cobalt pigments, Cobalt Blue is an extremely stable color with a soft velvety hue. It serves well as a primary blue. Because it has a high tonal value, it will not go dark.

Cobalt Blue is excellent for shading fleshtones or as a base for blue skies. It glazes wonderfully to indicate atmosphere or shadows in general.

◆ Characteristics
- Nonstaining
- Permanent
- Reflective
- Sedimentary
- Staining

❖ Colors with reasonably similar characteristics
Ultramarine Blues of most other brands (Daniel Smith, Holbein, Maimeriblu, Winsor & Newton), Holbein Verditer Blue, Cerulean Blues of most other brands (Daniel Smith, Maimeriblu, Rembrant and Winsor & Newton)

■ Complementary color
Yellow Orange

▲ Watch out for . . .
When mixed with earth colors in thick consistency, it may turn into a muddy gray, as if it were mixed with Ultramarine Blue.

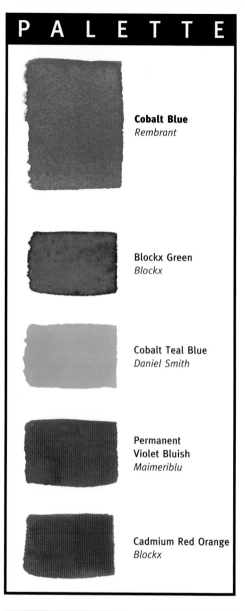

PALETTE

Cobalt Blue
Rembrant

Blockx Green
Blockx

Cobalt Teal Blue
Daniel Smith

Permanent Violet Bluish
Maimeriblu

Cadmium Red Orange
Blockx

REFERENCE PHOTO

1 I wanted my paper to be damp but not dripping wet, so I removed the surplus water by gently dragging tissues over the surface until the shine was gone. With Cobalt Blue in a 2-inch soft slant brush, I spread a light wash over the sky area, and charged the wash with Cobalt Teal Blue at the top and just a whisper of Cadmium Red Orange near the horizon. As the color lost its shine, I painted the darker point of land using a thicker mix of Cobalt Blue, Cobalt Teal Blue and Permanent Violet Bluish. I removed the clouds with a damp brush. Next, I added Cadmium Red Orange and painted the darker rocks in front of this shape. I followed with a rapidly dragged brush full of light paint, defining the edge of the horizon. Above this edge I painted the distant island, using the same colors in a darker value.

2 After the paper dried, I brushed in the sandy beach with a 2-inch flat soft slant brush and defined the negative edge of the water with the same shape, using Cadmium Red Orange and Permanent Violet Bluish. On the left, I painted the breezy shimmer by rapidly dragging my soft slant brush filled with a light mix of Cobalt Blue, Permanent Violet Bluish and Cobalt Teal Blue. I wet-blended the bottom edge of the resulting dry brushstroke. Above this shape I painted the dark silhouette of a closer rocky point with Cobalt Blue, Blockx Green and Permanent Violet Bluish charged with a little Cobalt Teal Blue.

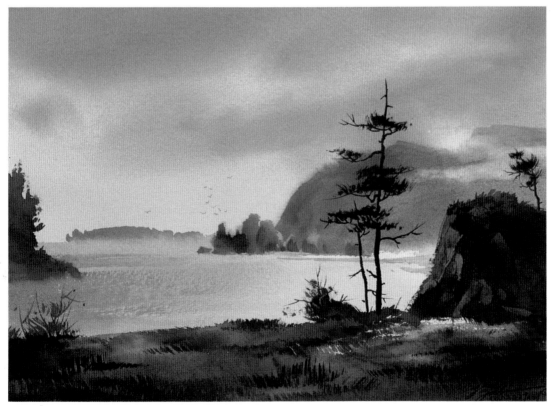

3 With my 1½-inch slant bristle brush filled with a very dark mix of Blockx Green, Permanent Violet Bluish, Cobalt Blue and Cadmium Red Orange, I defined the edge of the beach and the large rock formation on the right. After painting the big rock, I knifed out some lighter texture on it. I followed with the foliage of the pines and the grass using a no. 3 rigger.

Oregon Coast
Arches 300 lb. cold-pressed,
11″ × 15″ (28cm × 38cm)
Collection of Willa McNeill.

Cerulean Blue *Rembrant*

A stable blue pigment of light tonal value, Cerulean Blue is a lightly staining color but lifts fairly well from most of the popular rag papers. It dries with a velvety smooth surface. As an opaque color, it functions best when diluted in light wet washes.

Cerulean Blue is excellent for charging darker wet washes and is useful in fleshtones, sunny blue skies, spring foliage, sunny snow and so on.

◆ **Characteristics**
- Lightly staining
- Opaque
- Permanent
- Reflective
- Sedimentary

❖ **Colors with reasonably similar characteristics**
Cobalt Blue of most other brands (Blockx, Daniel Smith, Holbein, Maimeriblu and Winsor & Newton), Winsor & Newton Cobalt Turquoise, Rembrant Cerulean Blue Phthalo, Daniel Smith Cobalt Teal Blue, Winsor & Newton and Maimeriblu Cerulean Blue

■ **Complementary color**
Orange

▲ **Watch out for . . .**
Because of its weight, Cerulean Blue works best when used in the wet-in-wet technique.

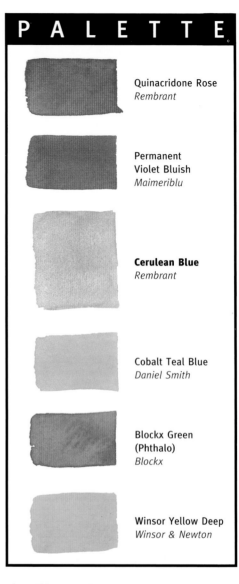

PALETTE

Quinacridone Rose
Rembrant

Permanent
Violet Bluish
Maimeriblu

Cerulean Blue
Rembrant

Cobalt Teal Blue
Daniel Smith

Blockx Green
(Phthalo)
Blockx

Winsor Yellow Deep
Winsor & Newton

REFERENCE PHOTO

1 An out-of-focus reference photograph suggested a slightly abstract approach to this painting. I painted the first wash of the background on a dry surface with a ¾-inch aquarelle brush. Working from left to right, I carefully painted around the negative silhouettes of the trees with Cerulean Blue, Cobalt Teal Blue and Permanent Violet Bluish. By the time I finished the last shape on the right, the left side was dry. I introduced a Cobalt Teal Blue-dominated mix, with Cerulean Blue, to enhance the richness of the first color and invent some new negative tree shapes.

2 I took advantage of the very light first wash by further darkening the background and leaving out new negative tree shapes. This deep wash was a combination of Blockx Green, Permanent Violet Bluish and a little Cerulean Blue. Switching to a 1½-inch soft slant brush, I painted the shading onto the white trees. For this step I loaded only the long-hair portion of the brush, leaving the short-hair portion moist but paint free. The right side of the stroke is lost as color is applied. My complementary pigments were Permanent Violet Bluish and Winsor Yellow Deep. I added yellow leaves for accent.

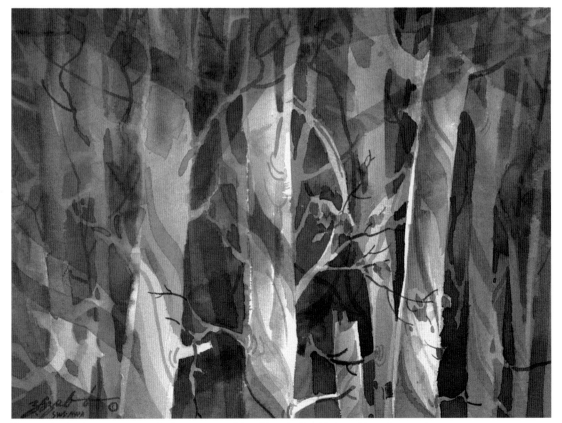

3 I enriched a few sections on the larger trees with a diluted mix of Quinacridone Rose and Winsor Yellow Deep in a 1-inch aquarelle brush. When dry, I painted curvilinear glazes over the light trees and background. I defined more of the bright leaves with a little Quinacridone Rose. With the no. 3 rigger, I completed the dark twigs in the front, using Permanent Violet Bluish and Cobalt Teal Blue crossing the light trees. I also added Blockx Green to the darker branches further back.

Dancing Blues
Arches 300 lb. cold-pressed,
11″ × 15″ (28cm × 38cm)
Collection of Susan and
Andrew Pearson.

Manganese Blue *Blockx*

This is a very intense color of light tonal value. In mixes on wet paper, it separates from transparent colors. When it is applied together with darker colors, it sparkles through the dry wash.

With its grainy sparkle, Manganese Blue is an effective color for cast shadows on snow. After drying, its nonstaining nature allows the sunlit patches to be lifted off completely.

◆ Characteristics
- Nonstaining
- Permanent
- Reflective
- Sedimentary
- Semitransparent

❖ Colors with reasonably similar characteristics
Daniel Smith Cobalt Turquoise, Holbein Manganese Blue, Rembrant Turquoise Blue

■ Complementary color
Orange

▲ Watch out for . . .
Because manganese pigment is harder and harder to find, some manufacturers substitute synthetic colors. The behavior of these colors is a little different from Manganese Blue.

PALETTE

Manganese Blue
Blockx

Blockx Green
Blockx

Permanent Violet Bluish
Maimeriblu

Quinacridone Red
Winsor & Newton

Permanent Yellow Lemon
Maimeriblu

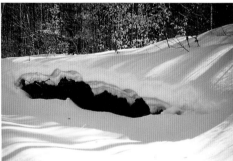

REFERENCE PHOTO

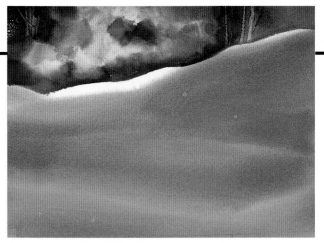 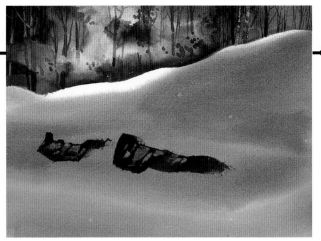

1 Because I had to have dry paint on the shaded snow area, I started this large shape by wetting it. Using a 2-inch soft slant brush, I painted a very rich wash mixed with Manganese Blue, Permanent Violet Bluish and a drop of Permanent Yellow Lemon. I mixed each brushful of paint with a little different dominance so the shadow color looked uniform but varied in color. While I worked on this wash, the top portion dried. With the same brush, I painted the colors of the forest, starting with Permanent Yellow Lemon charged with Quinacridone Red, Permanent Violet Bluish and a little Blockx Green. As the darker parts lost their shine but were still damp, I scraped off the light tree shapes with the slanted tip of an aquarelle brush handle.

2 To allow the foreground to dry, I worked on the trees in the background with a ¾-inch aquarelle brush. Where the branches were exposed, I painted them dark; where they were behind yellow foliage, I connected their shapes with much lighter and warmer colors. I mixed the cool dark colors from Permanent Violet Bluish and Blockx Green. For the medium-value brownish branches, I added Quinacridone Red and Permanent Yellow Lemon. When the snow was dry, I introduced the two rocks. I painted the smaller one first with a ¾-inch aquarelle brush filled with a rich, dark mix of Permanent Violet Bluish and Blockx Green and charged with a little Quinacridone Red. I knifed out the lighter texture while this wash was still damp.

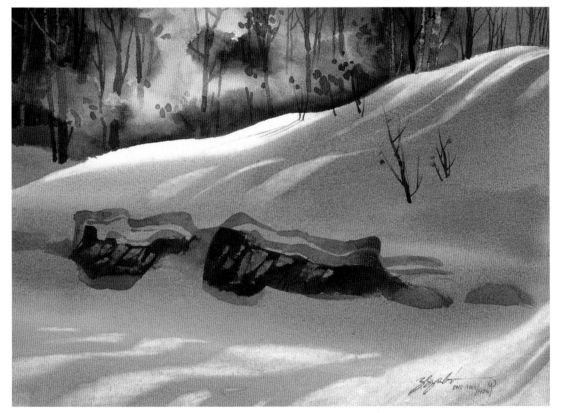

3 To create the sun spots, I moistened a section of the shaded snow with a ¾-inch aquarelle brush and blotted off the wet pigment with a tissue. I painted the wiggly snow shading over and under the rocks with the same brush. With a rigger brush, I accented the snow, adding a few young trees and the delicate shadows. My tree colors were the same as that of the rocks, and for the little shadows, the same as the snowy hill.

Winter's Stage Light
Arches 300 lb. cold-pressed,
11" × 15" (28cm × 38cm)

Cobalt Turquoise Light *Winsor & Newton*

Cobalt Turquoise Light is a very intense, extremely permanent blue of light tonal value. Its glowing beauty is most impressive when diluted and applied in thin washes. It stains lightly, though the strength of the stain varies from paper to paper.

This color is a common contributor to intense sky washes, grass, foliage and wherever brilliant greens are needed.

◆ **Characteristics**
- Lightly staining
- Opaque
- Permanent
- Reflective
- Sedimentary

❖ **Colors with reasonably similar characteristics**
Cerulean Blues of most other brands, Rembrant Turquoise Blue, Daniel Smith Cobalt Teal Blue

■ **Complementary color**
Red orange

▲ **Watch out for . . .**
Cobalt Turquoise Light creates mud when mixed in thick washes with earth colors and/or other opaques.

PALETTE

Cobalt Turquoise Light
Winsor & Newton

Ultramarine Violet
Winsor & Newton

Quinacridone Rose
Rembrant

Naples Yellow Deep
Rembrant

Cadmium Green
Holbein

REFERENCE PHOTO

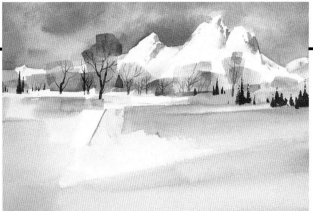

1 On dry paper, I painted the shape of the sky and defined the top edge of the mountain with a 2-inch soft slant brush. For this medium-value color I used Cobalt Turquoise Light and charged it with Permanent Violet Bluish and a touch of Cadmium Green. To contrast this cool shape, I painted the trees in front of the white mountain using a 1-inch aquarelle brush and a dominant hue of Naples Yellow Deep charged with Permanent Violet Bluish, Quinacridone Rose and Cobalt Turquoise Light. I repeated this color combination in the large foreground, but used a little more Cobalt Turquoise Light. In the sky area, I used predominantly curvilinear shapes; at the foreground, I used static (straight) shapes, and for the trees I mixed both.

2 I added definition to the trees by using all five colors in varied combinations. The overlapping transparent shapes not only represent the foliage on the trees but also show off the transparency of watercolor. I painted the calligraphic tree trunks and branches with a small no. 3 rigger. For the evergreens, I used a 1½-inch slant bristle brush filled with Permanent Violet Bluish and Cadmium Green. I modeled the mountains with the same color as the sky to suggest depth.

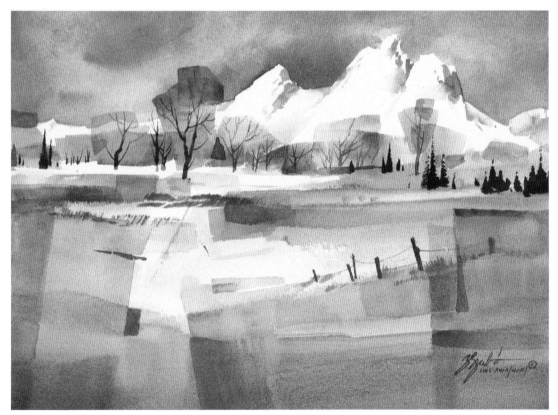

3 I now focused on the foreground. My 1½-inch soft slant brush catered to the dominant static edges. I used all the colors in light value and glazed them over each other, keeping in mind their upward movement. Although I reduced the volume of white, I carefully protected enough to echo the massive white of the mountain. For the finishing touch, I dropped in the small fence to give a sense of the scene's scale.

White Diamonds
Arches 300 lb. cold-pressed,
11″ × 15″ (28cm × 38cm)
Collection of Thadia and
Don George.

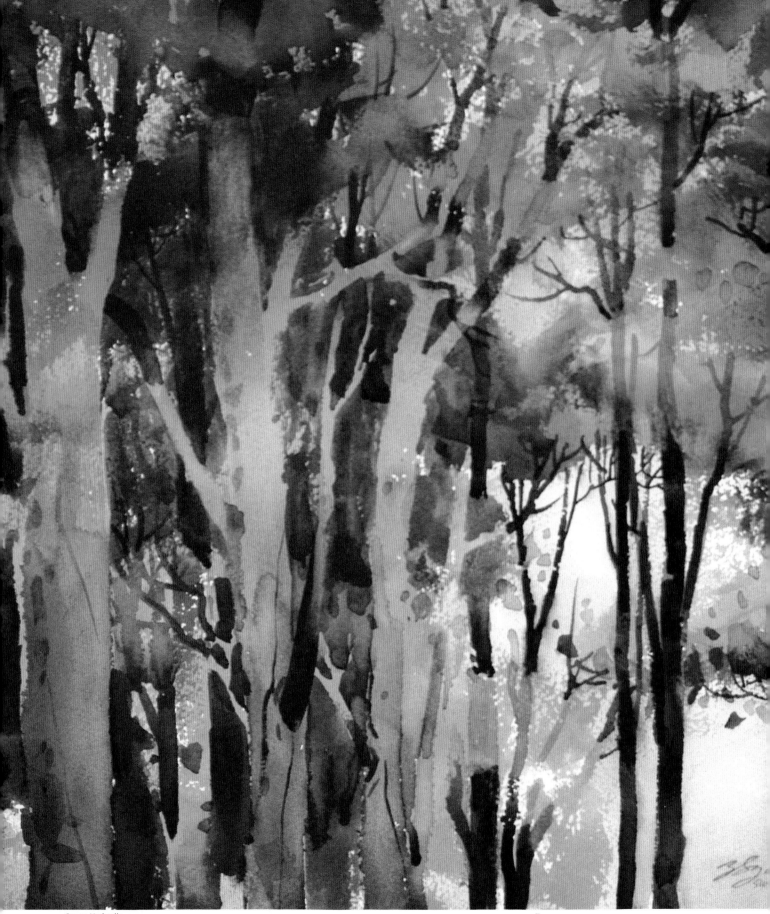

Green Umbrella
Lana 300 lb. cold-pressed,
15"×20" (38cm×51cm)

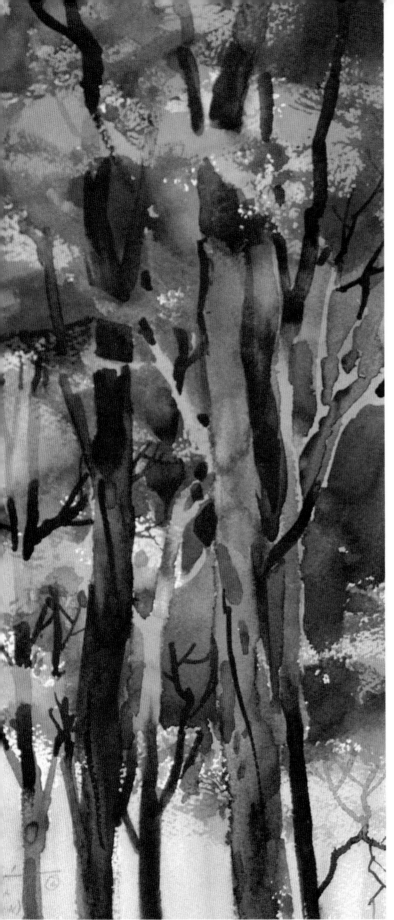

Greens

Greens are made from combinations of two primary colors: blues and yellows. This is why they are called secondary colors. Greens are found in the greatest abundance in landscapes. Variety in greens is important—a flat green is even more boring than other flat colors because psychologically we are used to nature's diversity of greens.

 I paint as a bird sings.''

—Claude Monet (1840-1926)

Phthalo Green *Rembrant*

Phthalo Green is a very transparent, intense bluish green with dark tonal value. Its purity is the reason for its tendency to dominate other washes. When mixed with transparent bluish reds like Winsor & Newton's Quinacridone Magenta or Permanent Alizarin, it results in a somewhat violet, transparent neutral black.

Phthalo Green is useful for cooling shadows by charging and darkening them, as a component color for shaded green foliage and as a local color for large bodies of water.

◆ **Characteristics**
- Staining
- True transparent

❖ **Colors with reasonably similar characteristics**
Winsor & Newton Winsor Green, Holbein Cadmium Green Deep, Daniel Smith Phthalo Green (blue shade), Hooker's Green Deep in most other brands (Daniel Smith, Holbein, Maimeriblu, Winsor & Newton)

■ **Complementary color**
Red orange

▲ **Watch out for . . .**
Although Phthalo Green is a wonderful mixing color, it is so strong that it is rarely useful by itself.

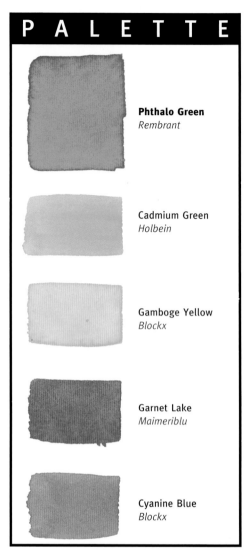

PALETTE

Phthalo Green
Rembrant

Cadmium Green
Holbein

Gamboge Yellow
Blockx

Garnet Lake
Maimeriblu

Cyanine Blue
Blockx

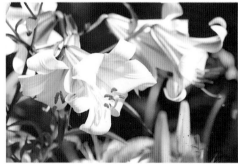

REFERENCE PHOTO

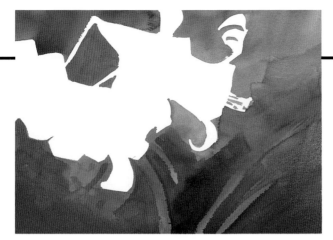

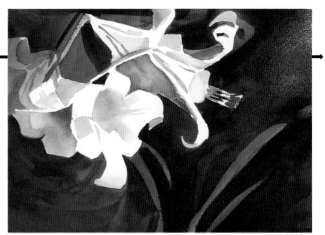

1 I painted the background on dry paper using a 1-inch aquarelle brush filled with a very dark mix of Phthalo Green, Cyanine Blue, Garnet Lake and Cobalt Green. I varied the dominance of colors within the dark value and painted around the flower cluster, making it a negative shape. I also indicated a few stem and leaf shapes entering from the bottom edge, allowing Cadmium Green to dominate them.

2 Switching to a ¾-inch aquarelle brush, I painted the shaded interior of the flowers. The occasional soft, blended edge is the result of brushing into the fresh wet shape with a thirsty 1-inch slant bristle brush and letting the edge disappear. The warm colors are a mixture of Gamboge Yellow and Garnet Lake. I painted the cool shaded petals with a combined wash of Cyanine Blue, Garnet Lake and a touch of Phthalo Green, and added a few strokes of pure Garnet Lake.

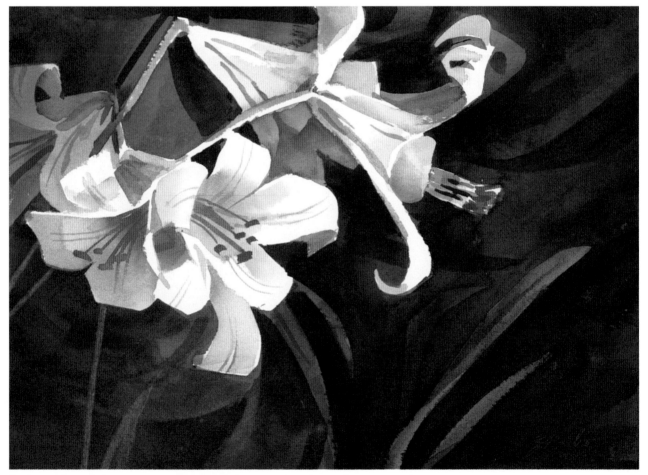

3 The petals needed a little more calligraphic definition to show their curly nature. For this I used a no. 3 rigger and applied the same colors I'd used earlier on the flowers, but much darker. From the dry background, I scrubbed off a few more stem and leaf shapes with the edge of a ¾-inch aquarelle brush, replacing the dark, cool background wash with a little lighter Cadmium Green.

Easter Messengers
Arches 300 lb. cold-pressed,
11″ × 15″ (28cm × 38cm)

Hooker's Green *Holbein*

Hooker's Green is an intense green with medium tonal value. Some brands offer a Hooker's Green Deep (bluish) and a Hooker's Green Light (yellowish) tint. This particular color is a little gentler than Phthalo Green, but a good match in transparency.

Hooker's Green provides a wonderful influence in washes of foliage, grass, water and sky.

◆ **Characteristics**
- Permanent
- Staining
- True transparent

❖ **Colors with reasonably similar characteristics**
Winsor & Newton Winsor Green (blue or yellow shade), Hooker's Greens of most other brands (Daniel Smith, Rembrant, Maimeriblu, Winsor & Newton), Sap Greens of Daniel Smith, Rembrant, Maimeriblu and Winsor & Newton

■ **Complementary color**
Yellow red

▲ **Watch out for . . .**
The differences among brands in properties of Hooker's Green require testing your own selections.

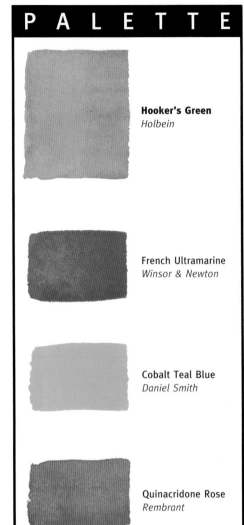

PALETTE

Hooker's Green
Holbein

French Ultramarine
Winsor & Newton

Cobalt Teal Blue
Daniel Smith

Quinacridone Rose
Rembrant

REFERENCE PHOTO

1 This was one of those times when color alone is capable of triggering an idea—where feeling is more meaningful than objective reality. I wet the paper and proceeded to dominate different subordinate areas with soft and light colors. I used a 2-inch soft slant brush and playfully applied Hooker's Green, as well as a mixture of the other three pigments, in slightly different dominance. After the surface lost its shine but while it was still damp, I drew the soft branch shapes right into the drying wash using a no. 3 rigger with only a little water. Using the same brush, I immediately painted the darker twigs with French Ultramarine and Hooker's Green.

2 Using a ¾-inch aquarelle brush on a completely dry surface, I glazed the background, protecting the negative shapes of the trees. I used the same colors as before in about the same value, but kept most edges sharp. I also introduced a few positive sections in addition to the negative shapes, such as in the bottom left portion. I didn't ignore the earlier soft branches, but linked them to the tree trunks, adding a few small leaf shapes around the soft green foliage.

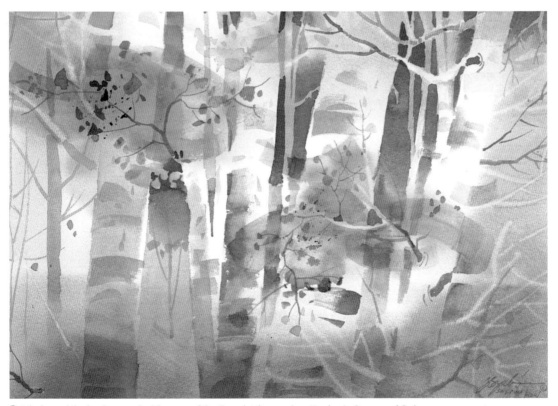

3 I darkened the background with more of the French Ultramarine, Hooker's Green and Quinacridone Rose combination, working around the existing light trees and creating new ones, using the light background color for new negative shapes. I defined more green leaves and added some reddish dry brushstrokes to the lower part of the largest white tree: This served as an isolated color to enhance the center of interest. I accented the top right exit of the largest tree by crossing it with a few positive branches created with my rigger. I stopped here because the delicate mood felt just right.

Forest Jewels
Arches 300 lb. cold-pressed,
11″ × 15″ (28cm × 38cm)
Collection of Willa McNeill.

Permanent Sap Green *Winsor & Newton*

Permanent Sap Green, a new color perfected by Winsor & Newton, behaves much like their old Sap Green, but is more permanent. It is an intense green with a medium tonal value. Its staining power dominates almost any combination in a mix. The hue of this color is very close to the sunny greens found in nature.

This color is good in autumn skies and deep water. It is ideal for indicating sunshine on grass or on foliage, and to excite reflected light in shadows.

◆ **Characteristics**
- Permanent
- Staining
- True transparent

❖ **Colors with reasonably similar characteristics**
Holbein Compose Green #3, Sap Greens of Daniel Smith, Rembrant and Maimeriblu, Winsor & Newton Hooker's Green

■ **Complementary color**
Yellow red

▲ **Watch out for . . .**
Used in a mixed wash, Permanent Sap Green will always show through if the wash is lifted.

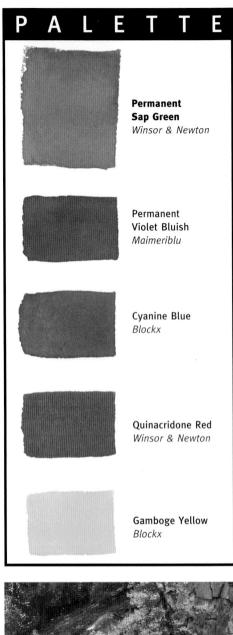

PALETTE

Permanent Sap Green
Winsor & Newton

Permanent Violet Bluish
Maimeriblu

Cyanine Blue
Blockx

Quinacridone Red
Winsor & Newton

Gamboge Yellow
Blockx

REFERENCE PHOTO

1 As soon as I wet the paper, I applied a rich load of Gamboge Yellow and a little Permanent Sap Green where the autumn tree was to be located. I worked with a 2-inch soft slant brush for all the large wet washes of this step. I quickly established the location of the big rock behind the tree using Permanent Violet Bluish and a little Cyanine Blue in a slightly darker value. I used an even darker mixture of Permanent Sap Green, Cyanine Blue and Permanent Violet Bluish to paint the forest. I imitated the shapes of soft evergreens as I advanced. When this wash was barely damp, I washed in the light lines with a no. 3 rigger, leaving a few soft impressions of light trees.

2 Using my ¾-inch aquarelle brush, I began clarifying the foliage layers and sharpening the outer edges of the big rock next to the background. First I scrubbed off the dark background behind the tree trunk to accommodate a negative section of the tree, and then painted the rest of the trunk with the same small brush, using Permanent Violet Bluish, Quinacridone Red and Permanent Sap Green. I added the calligraphic shapes of the branches and the dark crack in the rocks with a small no. 3 rigger.

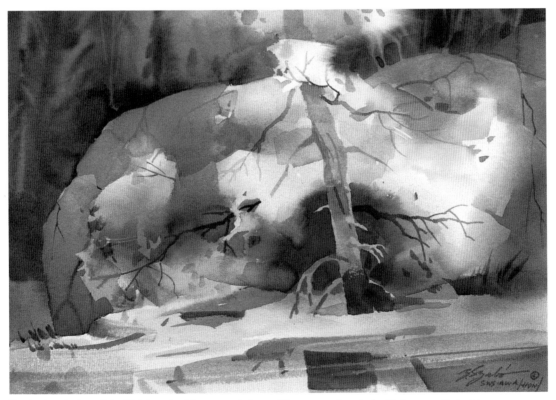

3 I further darkened the bluish rock with a second glaze of the same colors, but with the Permanent Violet Bluish a little stronger. I placed a few leaves on the perimeter of the brightly lit foliage: To deepen my yellow, I added Quinacridone Red to Gamboge Yellow, and for my dark green, I mixed Permanent Sap Green and Cyanine Blue with a touch of Gamboge Yellow. To balance the dominance of curvilinear shapes, I played with abstract shapes at the bottom using the same colors I had used in the rest of the painting, minus Gamboge Yellow.

Flashy Colors
Arches 300 lb. cold-pressed,
11″ × 15″ (28cm × 38cm)

Cadmium Green *Holbein*

Like most cadmiums, this yellow-green pigment is intense, extremely permanent and light in tonal value. It is most intense when applied in diluted light washes, and is an ideal pigment for charging darker wet washes because it has the capacity to declare the integrity of its hue without changing the value of the combined wash.

Cadmium Green is a fine color for sunlit grass or foliage, and works well in forest-interior shadows.

◆ Characteristics
- Lightly staining
- Opaque
- Permanent
- Reflective
- Sedimentary

❖ Colors with reasonably similar characteristics
Daniel Smith Permanent Green Light, Rembrant Permanent Yellow Green, Maimeriblu Permanent Green Light

■ Complementary color
Red violet

▲ Watch out for . . .
Like all opaques, in thick consistency Cadmium Green tends to get muddy when mixed with dark complementary colors.

PALETTE

Gamboge Yellow
Blockx

Cadmium Green
Holbein

Cyanine Blue
Blockx

Cobalt Teal Blue
Daniel Smith

Permanent
Violet Bluish
Maimeriblu

REFERENCE PHOTO

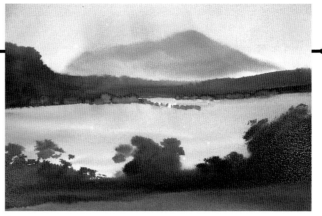

1 I wet the top half of the paper and began the sky with Cobalt Teal Blue, adding a touch of Cadmium Green to paint the center section. I continued with a 1½-inch soft slant brush. Before I painted the bluish distant mountain, I squeezed the water out of the brush and applied a mix of Permanent Violet Bluish and Cyanine Blue. While these colors were still damp, I painted the dark hills in the distance with a 1½-inch slant bristle brush, using Permanent Violet Bluish, Cyanine Blue and Cadmium Green. Near the lower edge I introduced some Gamboge Yellow droplets into the moist color, suggesting warmer trees.

2 I painted the bright green field with a watery mix of Gamboge Yellow, Cadmium Green and Cobalt Teal Blue. I did this wash with a 1-inch aquarelle brush. At this point I needed very dark colors, so I switched to a 2-inch slant bristle brush and mixed my wash as dark as possible without losing luminosity. My colors were Permanent Violet Bluish, Cyanine Blue and a touch of Cadmium Green. I rapidly painted in the silhouette of the dark foreground trees and the somewhat lighter blue-shaded grass at the bottom of the paper. The top edge of the trees turned fuzzy where the paper was still moist.

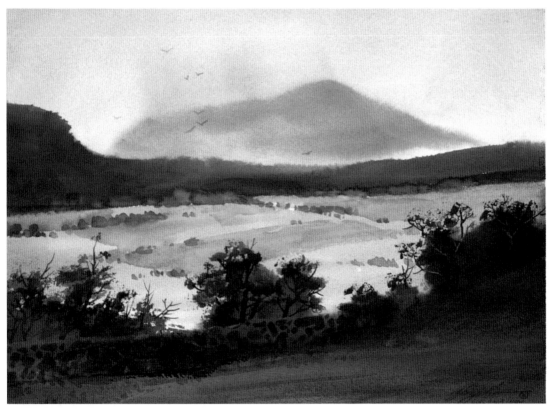

3 After everything was dry, I painted the distant fields and hedges with all the colors mixed in various combinations and strengths. When the foreground color dried, it became quite a bit lighter. Next, I glazed on the dark details of the trees, including the lacy perimeter and the stone wall, with the same dark colors on top of the first wash. For this I used a ¾-inch aquarelle brush, switching to a no. 3 rigger for the branches.

Mount Irish
Arches 300 lb. cold-pressed,
11″ × 15″ (28cm × 38cm)

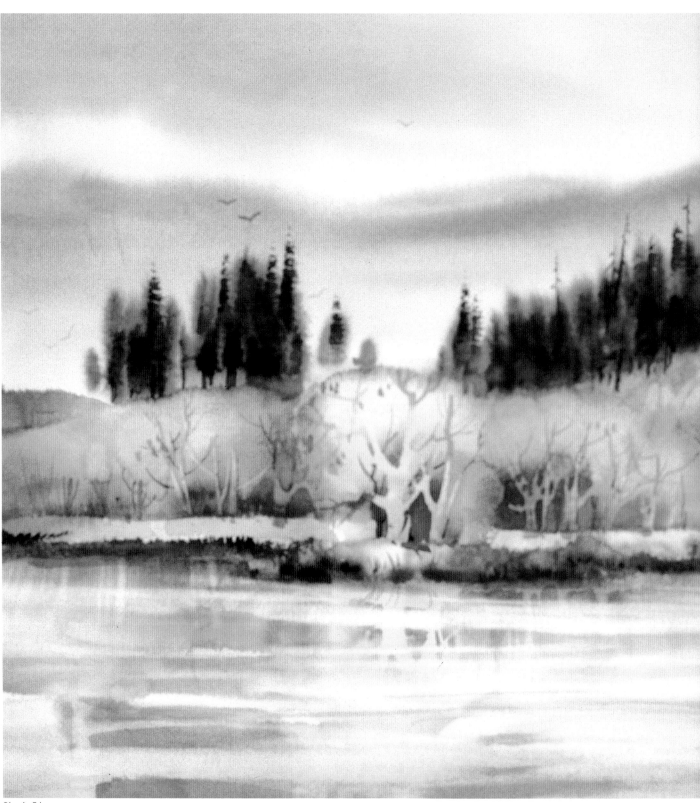

River's Edge
Arches 300 lb. cold-pressed,
15" × 20" (38cm × 51cm)

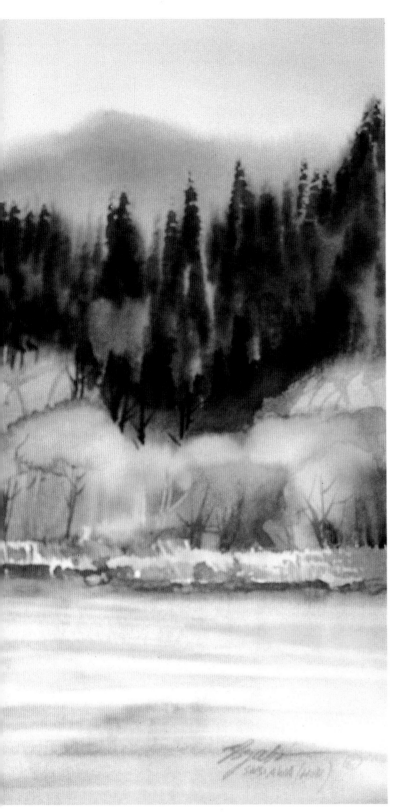

Yellows

Yellows are the most brilliant of the primary colors. Their principal qualities are brightness and reflective radiance. Nature presents these lively colors in great quantity: Yellows are found in the soothing warmth of sunlight and in the precious metal gold. Some religions honor saints with a golden halo as a sign of ultimate respect. Dominance of yellow in a painting suggests an uplifting, positive mood.

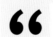

Light—dews—breezes bloom—and freshness; not one of which . . . has yet been perfected on the canvas of any painter in the world."

—John Constable (1776-1837)

Permanent Yellow Lemon *Maimeriblu*

Lemon Yellow

An intense, cool yellow, Permanent Yellow Lemon is an ideal primary hue with very light shade value. This color—from the new generation of transparent yellows—when applied with a glazing technique, will prevent the buildup of paste-like heavy pigment. It will also stay luminous even when heavy in consistency.

Permanent Yellow Lemon is very useful in fleshtones, flowers, summer or autumn foliage, grass and occasionally, skies.

◆ Characteristics
- Lightly staining
- Permanent
- True transparent

❖ Colors with reasonably similar characteristics
Daniel Smith Hansa Yellow Light, Holbein Permanent Yellow Lemon, Rembrant Permanent Lemon Yellow, Winsor & Newton Transparent Yellow

■ Complementary color
Violet

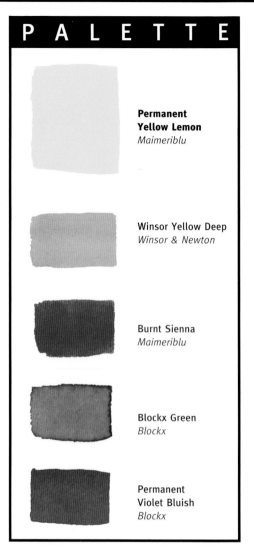

PALETTE

Permanent Yellow Lemon
Maimeriblu

Winsor Yellow Deep
Winsor & Newton

Burnt Sienna
Maimeriblu

Blockx Green
Blockx

Permanent Violet Bluish
Blockx

REFERENCE PHOTO

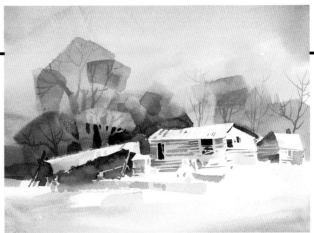

1 I brushed in the sky section on a dry surface with a 2-inch soft slant brush filled with Permanent Yellow Lemon, avoiding the top of the buildings. While this wash was still wet, I quickly charged it with Winsor Yellow Deep near the buildings, and with Permanent Violet Bluish near the top edge and the two corners. These washes dried quickly because I started on dry paper. Switching to a 1½-inch soft slant brush, I continued with the stylized shapes of the large trees' foliage. I also defined the grayish shaded sides of the structures using all the colors in gentle value, charging the warm and cool dominating colors with each other.

2 With a ¾-inch aquarelle brush, I increased the definition on the trees, with a generous use of negative and positive shapes. I turned the trunk of the largest tree into a negative shape by using a dark mix of Permanent Violet Bluish and Blockx Green next to it. Wherever I visualized branches behind the luminous foliage, I used the foliage color in darker value, adding Blockx Green, Burnt Sienna or both to Winsor Yellow Deep. I defined the buildings with medium and dark values, indicating logs on the sides and dark space behind the windows and doors with mixtures of Permanent Violet Bluish, Blockx Green and Burnt Sienna in varied dominance.

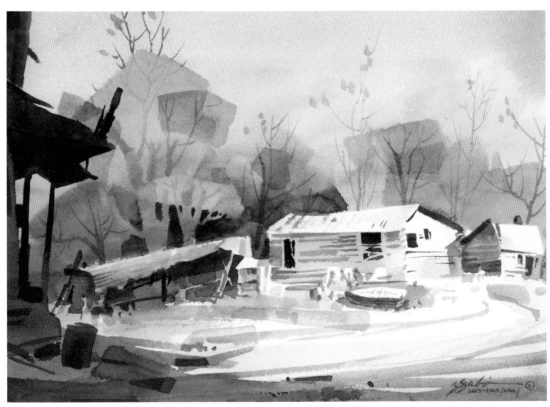

3 I now turned my attention to the foreground and painted the broken-down farm building and its shadow on the left side with a 1-inch aquarelle brush. I quickly painted the first layer with a combination of Blockx Green and Permanent Violet Bluish. I also added hints of the curving driveway and made sure to leave plenty of white. I glazed a darker version of the same colors, plus Burnt Sienna, on a dry surface to darken and warm the deepest values of the dilapidated building and the ground clutter next to it.

Needing Help
Arches 300 lb. cold-pressed,
11" × 15" (28cm × 38cm)
Collection of the artist.

Transparent Yellow

House yellow

Winsor & Newton

Transparent Yellow is an intense, light-value color with a glowing, luminous nature that makes it an excellent choice for transparent washes and glazes. This color's ancestor, Gamboge Yellow, was made from camel urine; this was replaced by the synthetically made New Gamboge. With the introduction of Transparent Yellow, Winsor & Newton has improved not only the color's chroma but also its permanence. The timely appearance of this transparent yellow makes glazing a joy.

Transparent Yellow is useful for influencing sunlit surfaces, autumn foliage, water, flowers and so on.

◆ **Characteristics**
- Lightly staining
- Permanent
- True transparent

❖ **Colors with reasonably similar characteristics**
Daniel Smith Hansa Yellow, Holbein Indian Yellow, Rembrant Azo Yellow Medium

■ **Complementary color**
Blue violet

PALETTE

Transparent Yellow
Winsor & Newton

Dragon's Blood
Maimeriblu

French Ultramarine
Winsor & Newton

Permanent Violet Bluish
Maimeriblu

Blockx Green
Blockx

REFERENCE PHOTO

 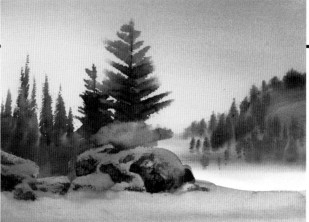

1 I wet the top two-thirds of the paper with a 2-inch soft slant brush. I painted the sky with Transparent Yellow near the horizon, and blended Permanent Violet Bluish and Dragon's Blood right through the top edge. With a 2-inch slant bristle brush, I painted the distant hillside into the damp color. With a medium-dark mix of French Ultramarine, Permanent Violet Bluish and Blockx Green, I filled the hill with evergreen shapes. For the larger, closer trees, I used a darker color and Blockx Green and Permanet Violet Bluish were dominant. At the foot of the tallest pine, I scrubbed off the wet color and replaced the dark blue-green with Dragon's Blood and Transparent Yellow.

2 Now it was time to paint the shaded snow in the foreground. I painted a medium-dark wash of French Ultramarine and Permanent Violet Bluish and let it dry. Using a 1½-inch aquarelle brush, I brushed in the shapes of the exposed rocks with Dragon's Blood, French Ultramarine and Permanent Violet Bluish in varied dominance, and then knife-textured them. After all the colors were dry, I darkened the snow below the rocks, using lost and found edges and the snow color used previously in a considerably darker value.

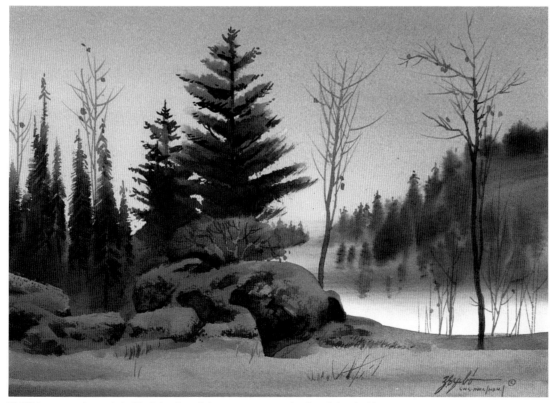

3 With a no. 3 rigger, I clarified the tips of the evergreens and painted the deciduous trees and their branches with Permanent Violet Bluish, Blockx Green and Dragon's Blood. I also accented the snow with a few grass blades using the snow color but darker and with some Blockx Green added. I used Dragon's Blood to deepen the color and define a few negative branches on the orange shrub. To continue the branches into positive twigs, I had the same dark color I used for the rocks in my rigger.

Lullaby
Arches 300 lb. cold-pressed,
11" × 15" (28cm × 38cm)
Collection of Pauline Gray.

Aureolin (Cobalt) Yellow *Blockx*

A warm, intense light yellow, Aureolin (Cobalt) Yellow has a light tonal value. Its almost transparent properties make this color an ideal candidate for glazing. An excellent component for greens, its warmth mellows them. It can be safely used to charge into darker washes without endangering their transparency.

Aureolin (Cobalt) Yellow is a natural color for autumn foliage particularly for tamarack trees. It is good in sunset skies, fleshtones, flowers, reflections and similar applications.

◆ Characteristics
- Nonstaining
- Reflective
- Semitransparent

❖ Colors with reasonably similar characteristics
Daniel Smith Hansa Yellow, Holbein Aureolin Yellow, Rembrant Azo Yellow Light, Winsor & Newton Transparent Yellow

■ Complementary color
Violet

▲ Watch out for . . .
Tubes of Blockx and some other brands of Aureolin Yellow accumulate gas while in storage and may burst, spraying color all over.

PALETTE

Aureolin (Cobalt) Yellow
Blockx

Cobalt Teal Blue
Daniel Smith

Blockx Green
Blockx

Permanent Violet Bluish
Maimeriblu

Quinacridone Rose
Rembrant

REFERENCE PHOTO

1 I wet the top half of the paper and dominated the background with Aureolin Yellow. I chose a 2-inch soft slant brush for this step because it spreads light and wet washes easily. For the sky area, I added Permanent Violet Bluish, and near the edge of the water I used Permanent Violet Bluish and Blockx Green. For the point of land on the left, I switched to a ¾-inch aquarelle brush and painted in the soft trees with Permanent Violet Bluish, Cobalt Teal Blue and Blockx Green, charging it with Aureolin Yellow in a few spots. I painted the water with the same colors as the top part but in stronger value.

2 I defined a few trees on the point of land with Permanent Violet Bluish and Aureolin Yellow with a no. 3 rigger. I moved to the right and painted the closer hill covered with darker trees. My ¾-inch aquarelle brush was ideally suited for the wet-modeled wash of Aureolin Yellow, Permanent Violet Bluish and Blockx Green, spottily applied with a definite Aureolin Yellow dominance. At the bottom edge, I added some Quinacridone Rose to the other colors to indicate soil, and then with a small rigger I dropped in the trunks and branches of the trees.

3 I brushed in the cyprus trees with a ¾-inch brush filled with with Quinacridone Rose, Aureolin Yellow and Permanent Violet Bluish. When dry, I painted the small branches and the texture on each tree with a rigger. Next I painted in the tree reflections with their own color and value, plus the dark local color of the water. I used the colors of the tree trunks, but applied Blockx Green and Permanent Violet Bluish in a much darker value. I could now see where the duckweed belonged. I extended the negative skips of the trees' reflections to darker dry-brushed shapes against the light water surface, adding Aureolin Yellow and Cobalt Teal Blue. Using the tip of a 1½-inch slant bristle brush, I drybrushed the Spanish moss and its reflections.

Southern Light
Arches 300 lb. cold-pressed,
11″ × 15″ (28cm × 38cm)

Gamboge Yellow *Blockx*

This intense, synthetic Gamboge Yellow is cooler than Cadmium Yellow. It can warm cooler hues without making them more opaque, behaving as a transparent Cadmium Yellow. Its high chroma makes this color equally enjoyable used alone or in a mix.

Gamboge Yellow is very useful in fleshtones, water, autumn foliage and flowers, or as a contributor to sunlit greens.

◆ **Characteristics**
- Lightly staining
- Permanent
- Reflective
- True transparent

❖ **Colors with reasonably similar characteristics**
Daniel Smith Hansa Yellow, Holbein Indian Yellow, Rembrant Azo Yellow Medium

■ **Complementary color**
Violet

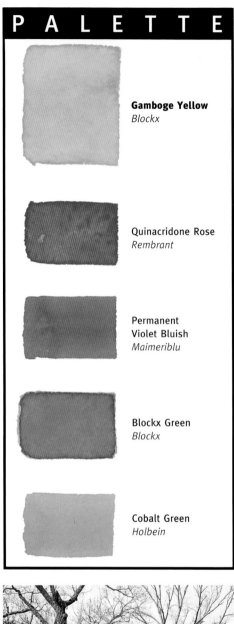

PALETTE

Gamboge Yellow
Blockx

Quinacridone Rose
Rembrant

Permanent
Violet Bluish
Maimeriblu

Blockx Green
Blockx

Cobalt Green
Holbein

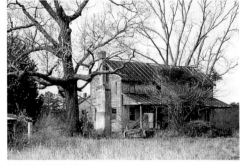

REFERENCE PHOTO

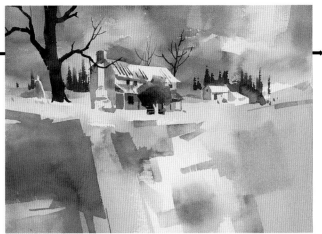

1 To give my background and foreground an exciting, united appearance, I spot-painted the dry surface with a 1½-inch soft slant brush, using all five colors in various combinations. As the abstract, colorful shapes mingled, I indicated the center of interest by leaving a sharp edge around a negative white roof of a building. I selected some spots where the colors were still wet and created softly blended edges with additional colors.

2 I used a 1½-inch soft slant brush to define the buildings. I glazed the shaded sides with a Permanent Violet Bluish and Blockx Green mix and charged it with Quinacridone Rose. I painted the big tree with a wash of Gamboge Yellow, Permanent Violet Bluish, Quinacridone Rose and a touch of Blockx Green. I darkened the branches and a few spots on the trunk with Blockx Green and Permanent Violet Bluish. I used this color to add windows and doors to the houses. Filling a 1½-inch slant bristle brush with a combination of Blockx Green and Permanent Violet Bluish, I painted the dark evergreens with repeating edgewise touches.

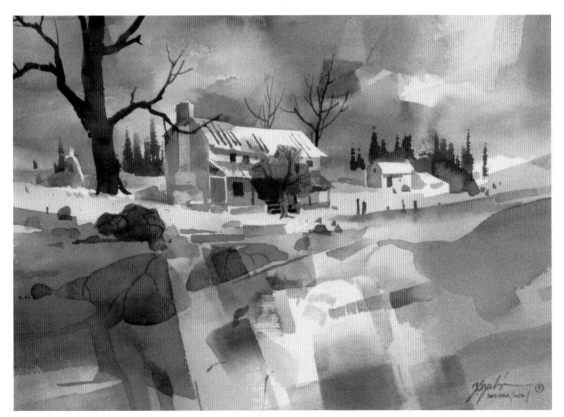

3 After adding the calligraphic trees above the large house with a no. 3 rigger, I moved to the foreground. As a lead in to my focal point, this area needed strengthening. I chose a 1½-inch soft slant brush to glaze the new shapes, and a rigger to make the rock silhouettes look cracked. My glazing colors were dominated by Permanent Violet Bluish and Blockx Green on the cooler left side; Quinacridone Rose and Gamboge Yellow strengthened the warm right side. I accented the whole foreground area with a light glow of Cobalt Green.

Golden Light
Arches 300 lb. cold-pressed,
11″ × 15″ (28cm × 38cm)

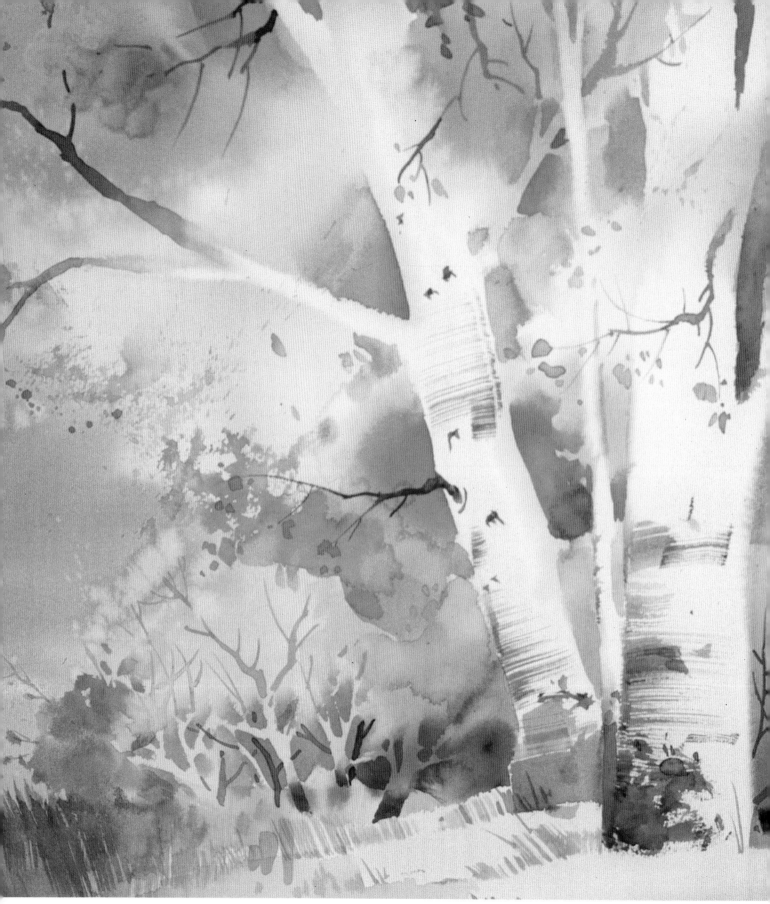

Behold Autumn
Lana 300 lb. cold-pressed,
15" × 20" (38cm × 51cm)

Oranges

Oranges form another secondary color family. Nature presents these colors—a blend of yellows and reds—whenever it declares strength and cheerful qualities together. Try to imagine a sunset or sunrise without plenty of orange. Many wildflowers, autumn foliage and the flames of a gently crackling fire are dominated by strong oranges: They are the colors of happy resignation, warmth and a cozy disposition.

 Color is my day-long obsession, joy and torment."

—Claude Monet (1840-1926)

Cadmium Yellow Orange *Holbein*

An intense color of medium value, Cadmium Yellow Orange is at its brilliant best used alone or in a mixed wash. When applied on dry paper with transparent blues, it granulates; on wet paper, it will separate from other pigments.

Cadmium Yellow Orange is ideal for flesh-tones, sunsets, fire, autumn foliage and flowers—wherever bright orange is needed.

◆ **Characteristics**
- Lightly staining
- Opaque
- Permanent
- Reflective
- Sedimentary

❖ **Colors with reasonably similar characteristics**
Cadmium Oranges of most other brands (Daniel Smith, Rembrant, Maimeriblu, Winsor & Newton), Daniel Smith Permanent Orange, Holbein Permanent Yellow Orange, Rembrant Permanent Orange, Winsor & Newton Winsor Orange

■ **Complementary color**
Greenish blue

▲ **Watch out for . . .**
It tends to dull a thick wash when mixed with darker complementary colors, such as dark blues.

PALETTE

Cadmium Yellow Orange
Holbein

Cadmium Red Orange
Blockx

Magenta
Blockx

Bluish Green
Rembrant

Cadmium Green
Holbein

REFERENCE PHOTO

1 I started this painting on wet paper using a 2-inch soft slant brush. I spot-painted the foliage shape with separate brushstrokes of individual colors, and let them blend as they touched. I used all five colors, with Cadmium Yellow Orange playing the strongest role. While the colors were still wet, I removed the shape of the light tree trunk with a wet-and-blot technique using a 1-inch aquarelle brush. As sections of the paper dried, I introduced a few glazes with sharp edges.

2 Next I painted the background in dark value with a 1-inch aquarelle brush using a dark mix of Magenta and Bluish Green. Because I had to protect the light negative shape of the foliage and branches, I painted the background in sections. As soon as I was finished with one area, I charged the wet wash with pure colors to vary the background without sacrificing the dark value.

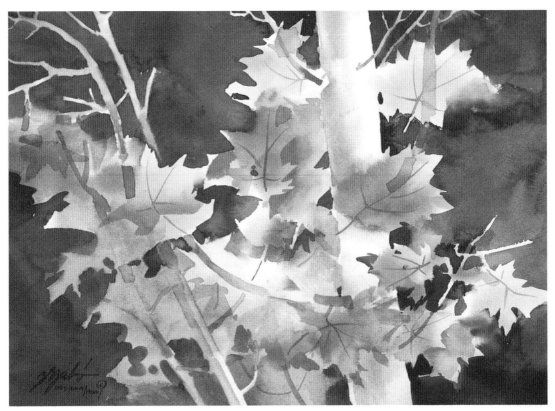

3 With a ¾-inch aquarelle brush, I glazed on a second layer of the same colors as in step 1, blending away one side of the brushstrokes and increasing the importance of the remaining sharp edge. I followed this by shading the left side of the leaves with a light glaze of Magenta and Bluish Green. For the finishing details, I painted the calligraphic veins of the leaves and stems, as well as the dark parts of the small twigs. Then I shaded the light tree trunk and added the reflecting colors into the wet shadow color of Magenta and Bluish Green.

Canada Day
Arches 300 lb. cold-pressed, 11″ × 15″ (28cm × 38cm)
Collection of Jayna B. and Steven J. Quinn.

Cadmium Red Orange *Blockx*

Like other cadmiums, this is an intense, deep orange with a medium tonal value. Excellent for charging darker washes, it adds a fiery glow when mixed with reds.

Cadmium Red Orange is useful in fleshtones, sunsets, fire, autumn foliage, flowers and so on.

◆ Characteristics
- Lightly staining
- Opaque
- Reflective
- Sedimentary

❖ Colors with reasonably similar characteristics
Daniel Smith Perinone Orange, Holbein and Winsor & Newton Cadmium Red Orange, Rembrant Cadmium Red Light

■ Complementary color
Blue green

▲ Watch out for . . .
Cadmium Red Orange is too red to be useful when mixing greens. It can warm up reddish violets; however, it may cause mud in thick washes when combined with dark blues, blue violets and blue greens.

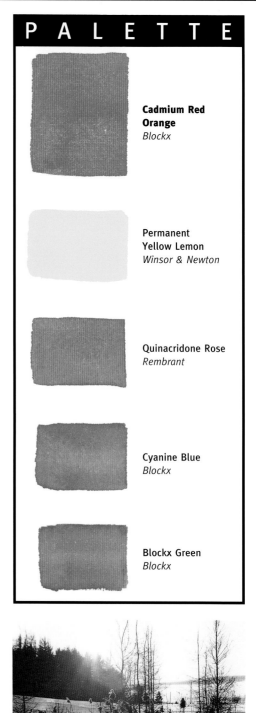

PALETTE

Cadmium Red Orange
Blockx

Permanent Yellow Lemon
Winsor & Newton

Quinacridone Rose
Rembrant

Cyanine Blue
Blockx

Blockx Green
Blockx

REFERENCE PHOTO

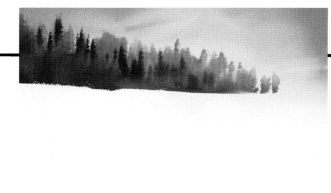

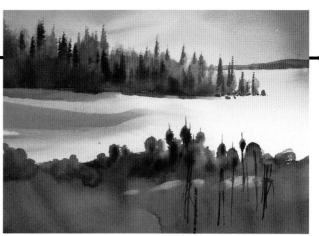

1 On a wet surface with a 2-inch soft slant brush, I applied Permanent Yellow Lemon near the center of the horizon. I added some Cadmium Red Orange on the outside of the yellow, and Quinacridone Rose and a touch of Cyanine Blue at the outer perimeter of the paper. Before the paper dried, I switched to a 1½-inch slant bristle brush filled with Cadmium Red Orange and Quinacridone Rose and painted the reddish backlit evergreens by simply touching the paper with the edge of the brush (its long-hair tip pointing downward). I repeated this technique with a mix of Cyanine Blue and Quinacridone Rose, and then again with a very dark combination of Blockx Green, Quinacridone Rose and Cyanine Blue.

2 I painted a distant hill on the right with a ¾-inch aquarelle brush filled with Cadmium Red Orange, Cyanine Blue and Quinacridone Rose. In the middle ground, I glazed on the soft violet shapes in the snow with a combination of Quinacridone Rose and Cyanine Blue. For the dark shaded foreground, I washed in a mix of Blockx Green, Quinacridone Rose and Cyanine Blue in varied dominance. Into this wet wash, at its upper edge, I painted the Cadmium Red Orange halo of the cattails. As this color spread into the wet shadow color, it added more moisture. After this wash dried, I lifted out some sunlit snow humps. For the dark center of the weeds and a few stems, I added a mix of Blockx Green and Cadmium Red Orange.

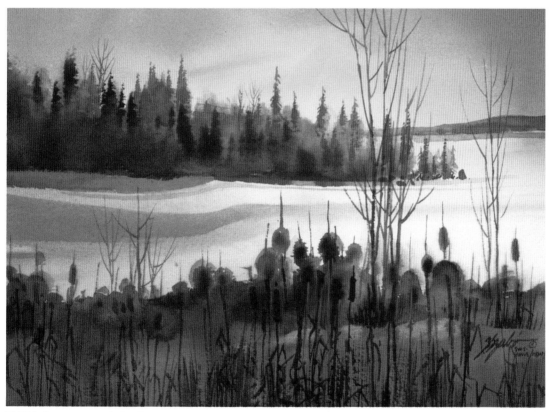

3 With the same very dark color in a no. 3 rigger, I added lots of stems, leaves and tall, young deciduous tree shapes. Where the sun's glow is the strongest, I painted Cadmium Red Orange opaquely over the dark stems to boost the shaded color's character and to echo some warm colors in the predominantly cool area. Finally, I tinted the snow spots in the shaded section with Permanent Yellow Lemon and Cadmium Red Orange.

Winter Sun
Arches 300 lb. cold-pressed,
11" × 15" (28cm × 38cm)

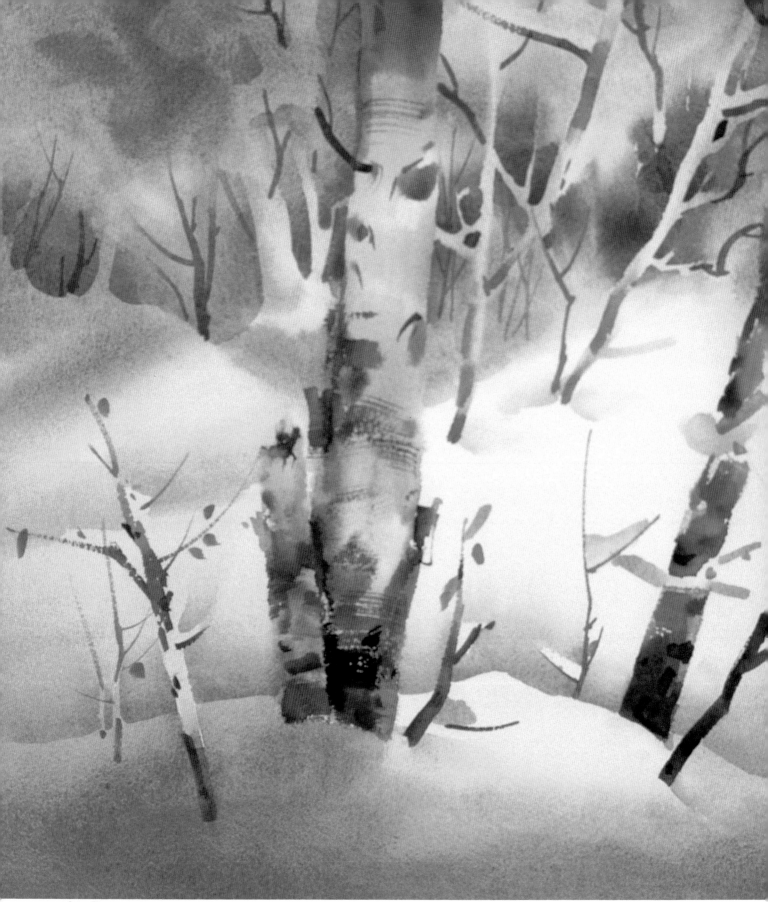

Snow Bouncers
Arches 300 lb. cold-pressed,
15" × 20" (38cm × 51cm)

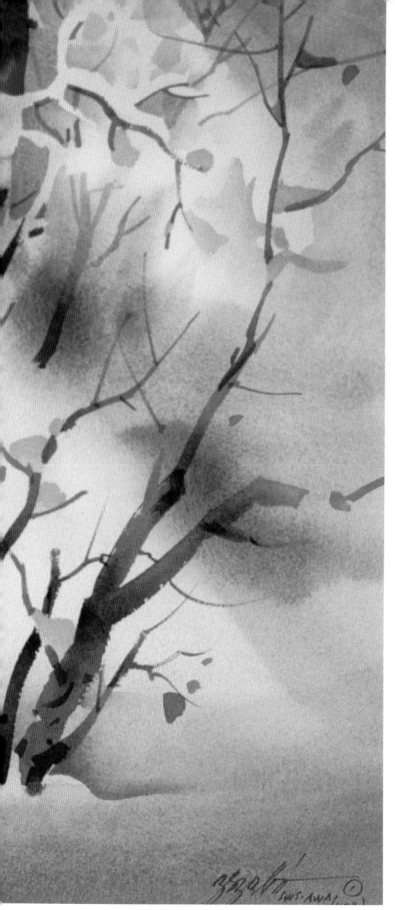

Neutrals

Neutrals can be warm or cool. Warm neutrals or browns are a mix of red, yellow and black. They are vital components for warm color temperature and color unity in a painting. Warm neutrals do their job best when used next to other warm colors. They have a tendency to build up to mud if they are mixed with or glazed over reflective blues. Warm neutrals are sensory in nature and function best as complements.

Calming and noncommittal, cool neutrals are usually grayed-down blues. The majority of these pigments tend to be transparent, which makes them wonderfully luminous complements to bright colors. However, when mixed with cleaner colors, they may dirty up the combination, particularly if their partner hues are opaque: Avoid overusing them.

> **"** *When it is dark, it seems to me as if I were dying, and I can't think anymore.''*
>
> —Claude Monet (1840-1926)

Raw Sienna _Maimeriblu_

A neutralized yellow of medium intensity and shade value, this particular earth color does not stain (although Raw Sienna is lightly staining in most other brands). When applied alone or mixed in a very thin wash, it glows. Its sedimentary grains contribute to dot-textured washes.

Raw Sienna is very effective when used in beach sand, gravel, mortar on walls, shading yellow foliage and weeds, and in similar applications.

◆ **Characteristics**
- Nonstaining
- Permanent
- Sedimentary
- Semitransparent

❖ **Colors with reasonably similar characteristics**
Raw Umber and Yellow Ochre of most other brands (Blockx, Daniel Smith, Holbein, Rembrant, Winsor & Newton), Daniel Smith Mars Yellow, Rembrant Transparent Oxide Yellow

■ **Complementary color**
Blue violet

▲ **Watch out for . . .**
Raw Sienna mixes well with analogous colors but can mud up in thick consistency when mixed with reflective blues—Ultramarine, Cobalt, Cobalt Turquoise and Cerulean.

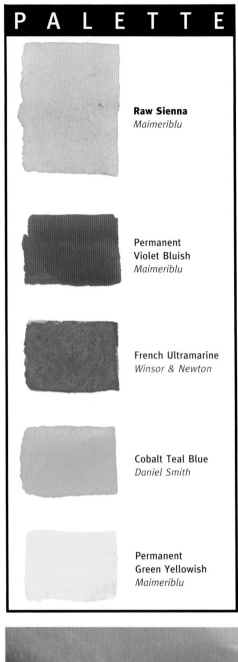

PALETTE

Raw Sienna
Maimeriblu

Permanent Violet Bluish
Maimeriblu

French Ultramarine
Winsor & Newton

Cobalt Teal Blue
Daniel Smith

Permanent Green Yellowish
Maimeriblu

REFERENCE PHOTO

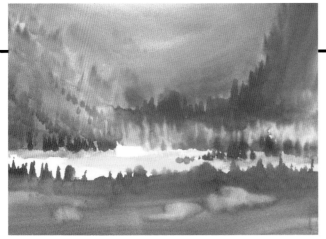

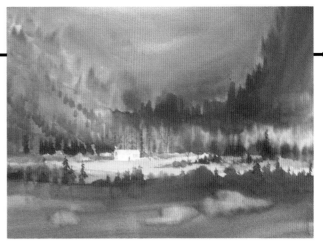

1 I wet the top two-thirds of the paper and washed in the mountains using 2-inch soft slant brush and French Ultramarine. I also hinted at background trees. On a drier surface, I established the larger trees. At the lower left side, I charged the color with Permanent Violet Bluish; on the right side of the house, I charged a combination of Permanent Green Yellowish and Cobalt Teal Blue, using a ¾-inch aquarelle brush. Next I painted around the house with Raw Sienna and Permanent Green Yellowish. For the dark warm foreground, I loaded a ¾-inch slant bristle brush with Permanent Violet Bluish, French Ultramarine and Raw Sienna and brushed in the whole shape. I charged this color with Raw Sienna for shrubs.

2 On a dry surface, using a ¾-inch aquarelle brush, I added a few details to the house and to the bottom edge of the background. I also finished the details in the sunny middle ground with Raw Sienna and Permanent Violet Bluish. With the same colors in a no. 3 rigger, I added character to the top edge of the foreground by defining the tops of a few evergreen shapes.

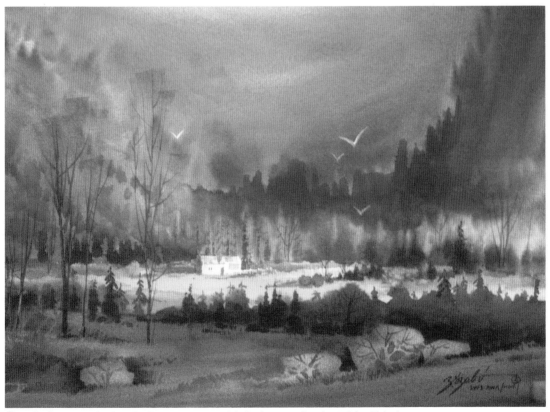

3 In the foreground I glazed a few evergreens with the base wash color. With a ¾-inch aquarelle brush, I painted around the shrubs. For negative and positive branches, I turned to the small rigger. I also painted the tall trees. For the buds at the top of the lanky trees, I glazed a few light Raw Sienna dry brushstrokes to echo warm colors in a cool-dominated area. Last, I made stencils out of masking tape and scrubbed off the white birds.

Smokies' Guard House
Arches 300 lb. cold-pressed,
11" × 15" (28cm × 38cm)
Collection of Ann and Ray
Stanhope.

Gold Ochre *Rembrant*

The name of this warm, fairly intense brownish yellow with medium shade value describes its warm glow. It is brighter and more transparent than the traditional ochre colors, behaving somewhat like a very bright Burnt Sienna. It can be glazed over a dry blue wash without turning green and mixes with its complementary colors without looking muddy.

Gold Ochre is a very practical color for grainy textures like sand, stucco and adobe.

◆ **Characteristics**
- Lightly staining
- Permanent
- Sedimentary
- Semitransparent

❖ **Colors with reasonably similar characteristics**
Daniel Smith Quinacridone Gold, Blockx and Winsor & Newton Gold Ochre

■ **Complementary color**
Blue violet

PALETTE

Gold Ochre
Rembrant

Quinacridone Red
Winsor & Newton

Permanent Violet Bluish
Maimeriblu

Blockx Green
Blockx

Cobalt Teal Blue
Daniel Smith

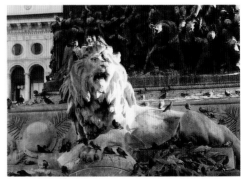

REFERENCE PHOTO

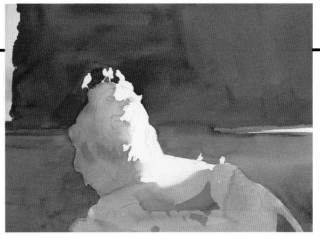

1 I began on dry paper, painting in the basic tone of the shadows with a 1-inch aquarelle brush, using Permanent Violet Bluish, Blockx Green and Cobalt Teal Blue charged with Gold Ochre to indicate reflected light warming the shadow. I also used Gold Ochre at the top left side to suggest a warm background.

2 I painted the large background wash with the same colors but in darker value. I darkened the top left side with Blockx Green and Permanent Violet Bluish. I painted around the lion's silhouette, making it a negative shape. I carefully protected the pure white area, which represents the strongest light and defines the drama of the moment.

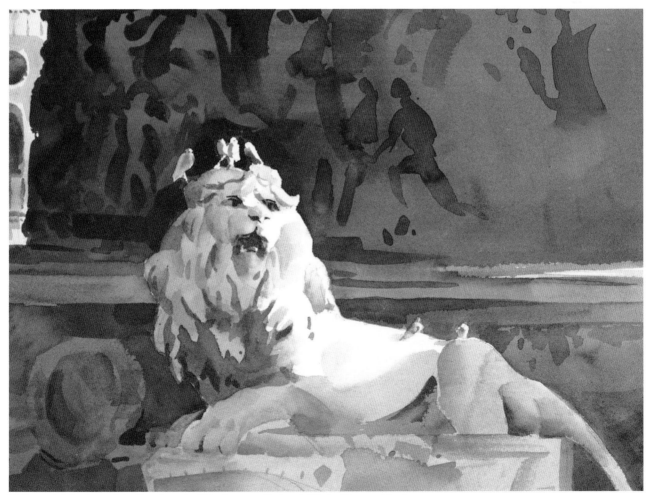

3 To model the form of the lion, I used a ¾-inch aquarelle brush filled with a combination wash of Gold Ochre, Quinacridone Red and Permanent Violet Bluish as a dark and warm color influence. For the darker, cooler details, I used the same shadow colors as before but in much darker value. At the top left part of the background, I scribbled very dark brushstrokes, suggesting both positive and negative figurative details.

The King
Arches 300 lb. cold-pressed,
11″×15″ (28cm×38cm)
Collection of Carol Athey.

Yellow Ochre *Daniel Smith*

Intense in light washes, this warm yellow's chroma will be reduced in thick consistency. Yellow Ochre is traditionally an opaque pigment, so this brand's surprising transparency is a welcome improvement. It mixes best with analogous colors or with transparent darks. It does not stain by itself. When in a mix with nonstaining complementary colors like Cobalt Violet or Manganese Blue, it is even easier to lift than when it is by itself.

This soft color is useful for fleshtones, rocks, tree trunks, sand and so on.

◆ Characteristics
- Nonstaining
- Reflective
- Sedimentary
- Semitransparent

❖ Colors with reasonably similar characteristics
Yellow Ochres of most other brands (Blockx, Holbein, Rembrant, Maimeriblu, Winsor & Newton), Mars Yellow of Daniel Smith, Holbein, Rembrant and Winsor & Newton, Naples Yellow of Winsor & Newton

■ Complementary color
Blue violet

▲ Watch out for . . .
Yellow Ochre may turn muddy in washes mixed with opaque blues such as Ultramarine, Cobalt, Cerulean and Cobalt Turquoise.

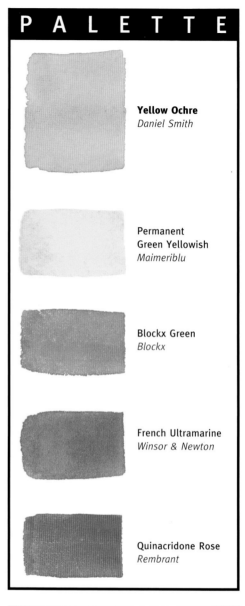

PALETTE

Yellow Ochre *Daniel Smith*

Permanent Green Yellowish *Maimeriblu*

Blockx Green *Blockx*

French Ultramarine *Winsor & Newton*

Quinacridone Rose *Rembrant*

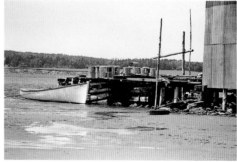

REFERENCE PHOTO

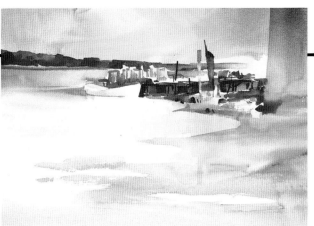

1 For the base washes, I used a 1½-inch soft slant brush and all the colors on my palette, except Blockx Green, allowing them to blend into each other while they were wet. The remaining white negative shapes represented the highest potential for contrast.

2 With a ¾-inch aquarelle brush, I painted the distant hill, using Blockx Green, French Ultramarine and a little Yellow Ochre. For the sunlit cargo above the white boat, my colors were Yellow Ochre and French Ultramarine. I started to define the dark pier and the side of the tall structure at the top right corner with a wash of French Ultramarine, Blockx Green and Quinacridone Rose. When this wash dried, I dropped in the darker details using a more concentrated application of the same colors. I shaded the outside of the white boat's hull with the same colors, and used just Yellow Ochre for the inside.

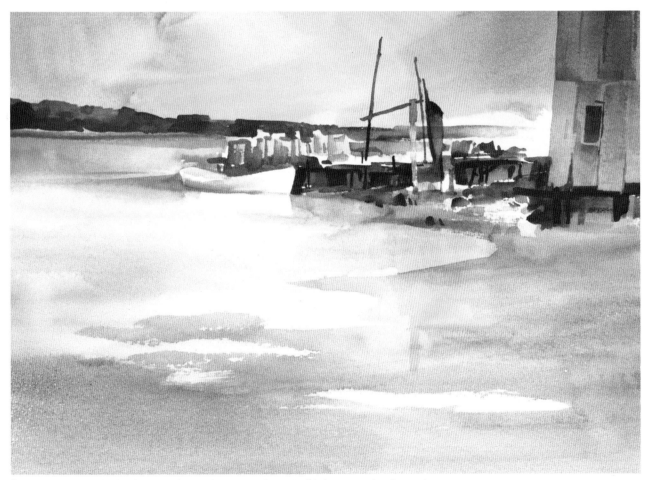

3 I continued with the finishing touches, using a no. 3 rigger. I added posts to the pier, and then the boards, the window and the dark understructure of the building at the top right. The strength of the composition is in the high contrast in color and value.

Neglected Corner
Arches 300 lb. cold-pressed, 11″ × 15″ (28cm × 38cm)
Collection of Carol and Luis Garcia.

Raw Umber *Rembrant*

A neutralized, dark greenish yellow of low intensity and shade value, in a mix with analogous colors it mellows and darkens the tonal value. Because it is a sedimentary color, it settles in dot-textured washes, similar to Raw Sienna, only darker. Most brands of Raw Umber stain lightly.

Raw Umber serves well for beach sand, rocks, tree bark, sun-tanned fleshtones, fence posts and similar applications.

◆ Characteristics
- Lightly staining
- Permanent
- Sedimentary
- Semitransparent

❖ Colors with reasonably similar characteristics
Raw Umbers and Raw Siennas of most other brands (Blockx, Daniel Smith, Holbein, Maimeriblu), Rembrant Sepia and Vandyke Brown

■ Complementary color
Violet

▲ Watch out for . . .
Raw Umber, like most other earth colors, turns to mud in thick mixes with reflective blues.

PALETTE

Raw Umber
Rembrant

Winsor Yellow Deep
Winsor & Newton

Magenta
Blockx

Blockx Green
Blockx

Cobalt Teal Blue
Daniel Smith

REFERENCE PHOTO

1 I defined the silhouette of the structures and the fence sections. On a dry surface with a 1½-inch soft slant brush, I blocked in the large shapes, starting with the sky in a medium-value mixture of Magenta, Blockx Green and Raw Umber. While this wash was drying, I painted the walls on both sides of the white building using the same brush and mingling all five of my palette colors in large, warm-dominated shapes. I painted around the fence boards and roof sections. In the low foreground, I painted colorful washes dominated by Cobalt Teal Blue, Magenta and a little Winsor Yellow Deep.

2 I continued by glazing the dark inner spaces with a ¾-inch aquarelle brush filled with a mix of Blockx Green and Magenta. I also painted the large tree with the same dark colors over the sky wash. To give form to the fence boards, I shaded them on the left side with a rigger and Winsor Yellow Deep, Magenta, Raw Umber and Blockx Green.

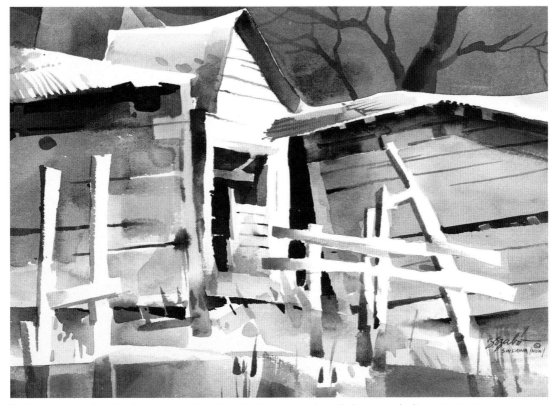

3 Now I had to refine the details. I used the rigger for the lines and small shapes, and a ¾-inch aquarelle brush for the larger shapes. I reshaped the top roof and textured the one below it. In the foreground I strengthened the washes by overlapping them with medium-dark glazes, extending the vertical boards through the bottom edge. Finally, I added Raw Umber to indicate signs of age, such as at the foot of the fence boards. The old buildings really look as if they are falling apart, yet the details are suggested with only clean, glowing colors. The Raw Umber alone delivers the necessary patina effect and unifies the composition.

Holding On
Arches 300 lb. cold-pressed,
11″ × 15″ (28cm × 38cm)

Burnt Sienna *Maimeriblu*

A neutralized orange of medium intensity and shade value, this earth color's staining strength varies considerably from brand to brand. It is most beautiful when applied in light washes, but can be mixed with other transparents (particularly analogous colors) without much change in intensity, transparency and shade value.

Burnt Sienna is a wonderful contributor to shadows and mellow green or autumn foliage. When strongly diluted and mixed with Ultramarine, the resulting light wash is perfect for clouds and overcast-snow modeling.

◆ **Characteristics**
- Lightly staining
- Permanent
- Sedimentary
- Semitransparent

❖ **Colors with reasonably similar characteristics**
Winsor & Newton Burnt Sienna

■ **Complementary color**
Blue

▲ **Watch out for . . .**
When mixed in thick consistency with reflective blues—Ultramarine, Cobalt, Cobalt Turquoise, Cerulean Blues—the wash always goes muddy.

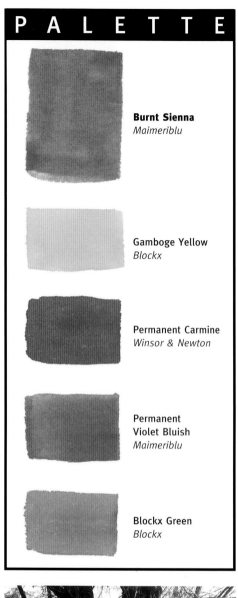

PALETTE

Burnt Sienna
Maimeriblu

Gamboge Yellow
Blockx

Permanent Carmine
Winsor & Newton

Permanent
Violet Bluish
Maimeriblu

Blockx Green
Blockx

REFERENCE PHOTO

1 Although my paper was dry, I quickly applied the pale background with a 2-inch soft slant brush to appear as wet-into-wet, using all five colors in light value and varied dominance. The protected white shape will become the high contrast center of interest. With Blockx Green and Permanent Violet Bluish, I hinted at ground clutter next to the white shape as well as at the bottom edge of the paper. I added a few clean-water strokes into the drying color to suggest light weeds.

2 After the wash dried, I glazed a very pale hint of trees and an old fence to the right middle ground. With Burnt Sienna dominant, but all the other colors contributing, I painted the base washes for the two large trees. While these washes were still damp, I scraped out a few light bark lines from the dark color.

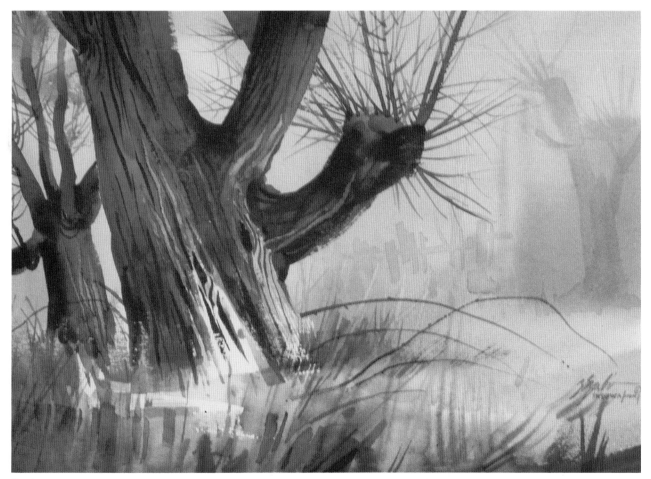

3 Using a small rigger, I painted the mesh of lines representing small branches and dark texture on the tree bark, as well as the vines at the base of the large tree. My dominant color was Burnt Sienna, but I also used all the other colors to achieve variety in these sensitive, delicate lines. Finally, I created a gentle rhythm in the grass at the foot of the large tree by playfully crossing the overwhelmingly vertical shapes with light horizontals.

Never Say Die
Arches 300 lb. cold-pressed,
11″ × 15″ (28cm × 38cm)

Indian Red *Rembrant*

Indian Red—a neutralized red—is an earth color of medium intensity and tonal value. It is useful for mixing a wide range of extremely lush reddish browns in middle values.

Useful in desert rock formations, adobe buildings, fleshtones, flowers and so on.

◆ **Characteristics**
- Lightly staining
- Opaque
- Permanent
- Reflective
- Sedimentary

❖ **Colors with reasonably similar characteristics**
Daniel Smith Permanent Brown, Rembrant and Maimeriblu Venetian Red, Rembrant Light Oxide Red, Daniel Smith, Holbein and Winsor & Newton Indian Red

■ **Complementary color**
Green

▲ **Watch out for . . .**
Though it is not a staining color, Indian Red still resists lifting from some papers after drying because of its great density.

PALETTE

Indian Red
Rembrant

Green Gold
Winsor & Newton

Blockx Green
Blockx

**Permanent
Violet Bluish**
Maimeriblu

Gamboge Yellow
Blockx

REFERENCE PHOTO

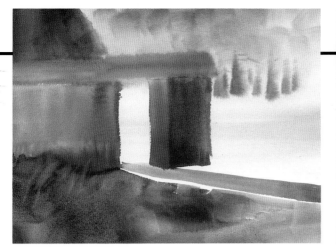

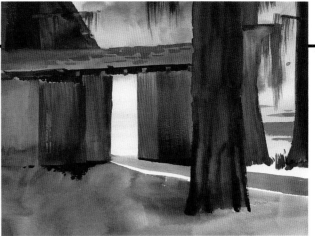

1 Aware of the opaque nature of my key color, I first wet the paper, reducing the possibility of the color staying thick. Next I painted the distant trees with a 1½-inch soft slant brush using Gamboge Yellow, Blockx Green and a touch of Indian Red. I painted the bluish water with Blockx Green and Permanent Violet Bluish. With the same color combination in darker value, I applied the shaded side of the structure. I followed with the roof and boardwalk, using a ¾-inch aquarelle brush filled with Indian Red and Gamboge Yellow. For the angular roof at the top left and for the foreground, I used all five colors in a dark wet wash, allowing each color to dominate separate areas.

2 After the paper dried, I sharpened the edges of the building with a ¾-inch aquarelle brush, and hinted at the texture on the corrugated metal and the horizontal roof. I touched up the details with a no. 3 rigger. Next I painted the bases of the cyprus trees with Indian Red, Permanent Violet Bluish and Blockx Green. I switched to a 2-inch slant bristle brush and drybrushed the Spanish moss hanging from a few broken branches.

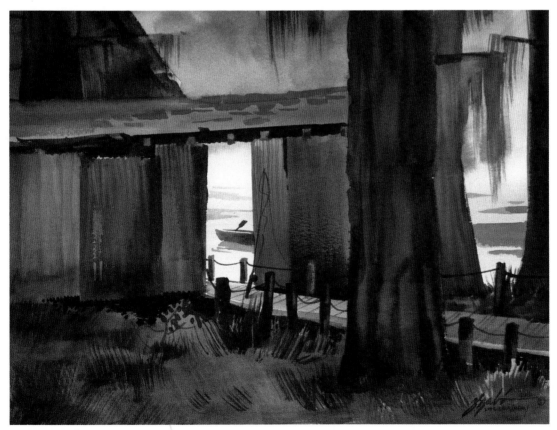

3 I continued with the short posts supporting the boardwalk, using a ¾-inch aquarelle brush with Indian Red, Permanent Violet Bluish and Blockx Green. I repeated a few more grass clusters in the foreground with a 2-inch slant bristle brush. I used a no. 3 rigger to paint the fishing rod leaning against the gate, as well as the partially exposed boat and its reflections.

Gone Fishing
Lana 300 lb. cold-pressed,
11″ × 15″ (28cm × 38cm)

Burnt Umber *Blockx*

This warm-brown earth color is a neutralized dark orange with low intensity and tonal value. It blends well with reds and yellows (analogous colors) and can deepen and mellow light washes of transparent greens and blues (Phthalo, Antwerp, Prussian and Cyan Blues, and Hooker's and Sap Greens).

It is excellent for dark-complexion fleshtones, forest interiors, warming up nighttime subjects and similar applications.

◆ **Characteristics**
- Lightly staining
- Opaque
- Permanent
- Sedimentary

❖ **Colors with reasonably similar characteristics**
Vandyke Brown, Sepia and Warm Sepia of most other brands (Daniel Smith, Holbein, Rembrant, Maimeriblu), Rembrant Trans Oxide Brown

■ **Complementary color**
Blue

▲ **Watch out for . . .**
Burnt Umber turns muddy when it is mixed with reflective blues.

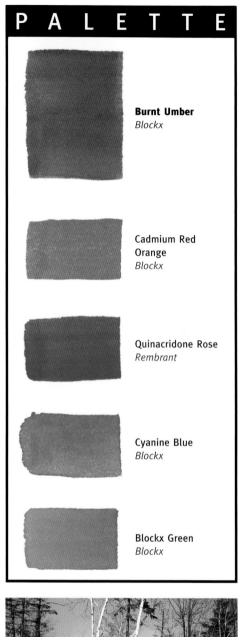

PALETTE

Burnt Umber
Blockx

Cadmium Red Orange
Blockx

Quinacridone Rose
Rembrant

Cyanine Blue
Blockx

Blockx Green
Blockx

REFERENCE PHOTO

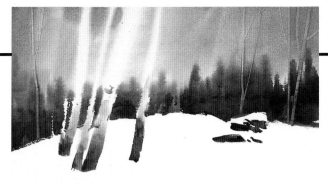

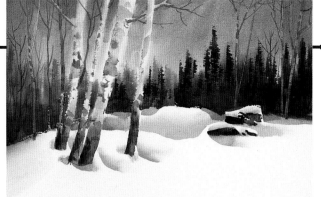

1 I dampened the top two-thirds of the paper with a light wash of Blockx Green and Quinacridone Rose, leaving the birch trees white. With a barely damp brush, I picked up concentrated dark paint with varied dominance to paint the evergreens. Note the Cadmium Red Orange trees just above the rocks: I charged this color into the damp background and replaced the dark color with the lighter rusty hue. As the color was losing its shine, I scraped off a few light tree shapes with the tip of my brush handle. I painted the dark shapes of the boulders with Burnt Umber, Quinacridone Rose and Blockx Green in a ¾-inch aquarelle brush. Using the same colors in lighter value, I painted the birch bases against the white snow.

2 After the paper dried, I glazed the evergreens again exactly the same way as before, using the 2-inch slant bristle brush, but this time the tree tops stayed sharp and dark on the dry surface. With my ¾-inch aquarelle brush, I sharpened the blurry white edges of the birch trees with the sky color, using the lost-and-found-edge technique. Similarly, I glazed the different dips in the snow using Blockx Green, Cyanine Blue and Quinacridone Rose in very light value. I also painted the patches onto the birch bark.

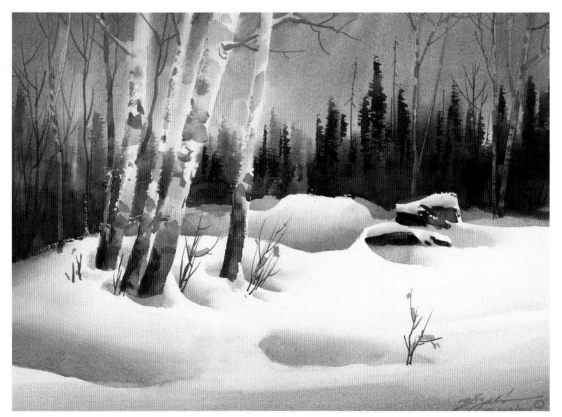

3 I added a few more large dips to the snow in the foreground and lost their top edges until the wash blended away into nothingness. With a no. 3 rigger, I painted the smaller branches and the little twigs in the snow. For these calligraphic shapes, I used Burnt Umber, Cadmium Red Orange and some Blockx Green. For my final touch I indicated a few dried leaves on the shrubs using only Cadmium Red Orange in light value.

Happy Family
Lana 300 lb. cold-pressed,
11″ × 15″ (28cm × 38cm)
Collection of Jacqueline Henness.

Indigo _Holbein_

A dark, grayish blue with medium intensity and dark tonal value, Indigo is useful in angry, stormy skies or as a cool influence in deep shadows, as well as in some rocks, steel and reflections on chrome.

◆ Characteristics
- Lightly staining
- True transparent

❖ Colors with reasonably similar characteristics
Payne's Gray and Indigo of most other brands (Blockx, Daniel Smith, Holbein, Maimeriblu, Rembrant, Winsor & Newton), Daniel Smith Indanthrone Blue

■ Complementary color
Orange

▲ Watch out for . . .
Indigo's usefulness is limited because of its tendency to dirty colors in a mixed wash. In this respect, the most vulnerable colors are its complementary colors—yellows, oranges and warm reds, particularly cadmiums. It does not mix well with earth colors, either, especially in dark values.

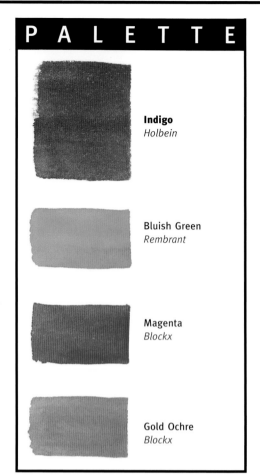

PALETTE

Indigo
Holbein

Bluish Green
Rembrant

Magenta
Blockx

Gold Ochre
Blockx

REFERENCE PHOTO

1 On dry paper using a 2-inch soft slant brush loaded with Indigo and a little Magenta, I painted the angry sky, leaving the top edges of the buildings sharp and white. After this color dried, I painted the hilltop on the left side with a mix of Indigo, Magenta and Gold Ochre. Again I painted around the left side of the building, leaving the edges sharp. Next I switched to lighter colors, dominated by Gold Ochre, Magenta, Bluish Green and a few drops of Indigo, and roughed in the base wash of the foreground.

2 I continued by applying some details of the brightly lit walls of the houses using Magenta and Gold Ochre. For the shadows and the base washes of the stone walls, I used Bluish Green, Magenta and a little Indigo. I reduced the volume of the white shapes, but left their edges decidedly sharp.

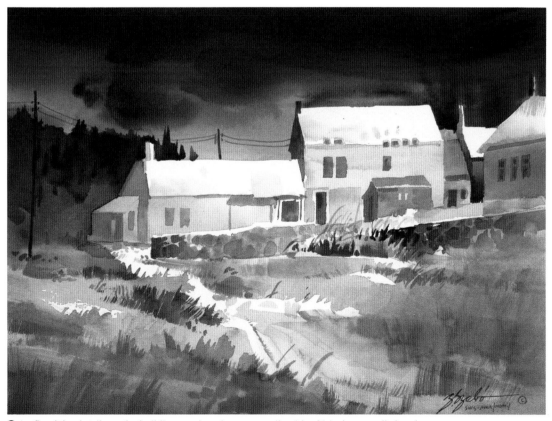

3 I refined the details on the buildings and on the stone walls with a ¾-inch aquarelle brush. For the dark grass clumps in the foreground, I used a 2-inch slant bristle brush with a dry-brush technique. To increase the strength of the white in the middle ground, I glazed a gentle wash over most of the foreground, using a 2-inch soft slant brush with Indigo and Gold Ochre. While this color was still wet, I painted more grass clumps with the slant bristle brush, this time mixing my color from Bluish Green, Magenta and Indigo.

Friendly Neighborhood
Lana 300 lb. cold-pressed,
11″ × 15″ (28cm × 38cm)

Payne's Gray _Blockx_

An intense, bluish-gray color of medium shade value. Because it tends to dominate other colors, it is a popular color for neutralizing bright, high-chroma hues with a cool tone. However, it works best when other colors dominate it in a combined wash. The transparent nature of this color allows it to be useful, even in darker washes, without going muddy or anemic. It is a wonderful glazing color.

Payne's Gray is particularly useful in angry storm clouds; it is also good in shadows and skies and for reflections in metal.

◆ **Characteristics**
- Lightly staining
- Permanent
- True transparent

❖ **Colors with reasonably similar characteristics**
Payne's Gray of most other brands (Daniel Smith, Holbein, Maimeriblu, Rembrant, Winsor & Newton), Neutral Tint (Holbein, Maimeriblu, Rembrant, Winsor & Newton), Indigo (Daniel Smith, Holbein, Maimeriblu, Rembrant)

■ **Complementary color**
Orange

▲ **Watch out for . . .**
Tubes of this Payne's Gray tend to accumulate gas while in storage and can burst, spraying color all over. Exercise caution when opening a new tube: Point the cap away from you.

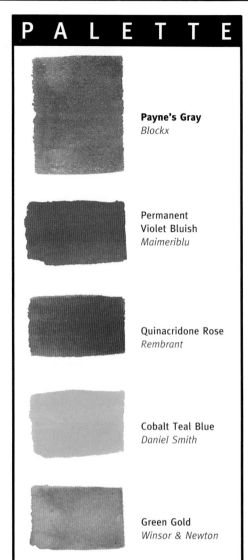

PALETTE

Payne's Gray
Blockx

Permanent Violet Bluish
Maimeriblu

Quinacridone Rose
Rembrant

Cobalt Teal Blue
Daniel Smith

Green Gold
Winsor & Newton

REFERENCE PHOTO

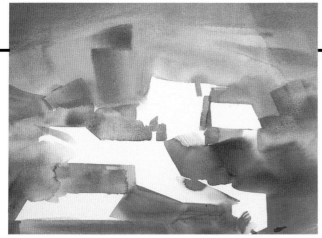

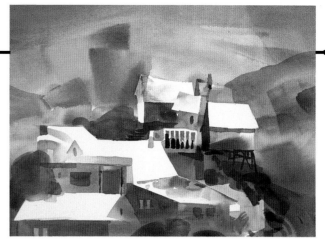

1 In this painting, I used my key color (Payne's Gray) only at the very end, and even then only as a glaze. On dry paper, I began by boldly and quickly painting the background with a 2-inch soft slant brush. I used Cobalt Teal Blue, Green Gold and Permanent Violet Bluish in varied dominance and in light value. I continued with the golden trees, using a rich load of Green Gold and a touch of Permanent Violet Bluish. Advancing through the middle ground, I picked up more paint and less water and dominated my washes with Permanent Violet Bluish charged with Cobalt Teal Blue and Green Gold.

2 I switched to a ¾-inch aquarelle brush and painted a few shaded walls, doors and some details on the houses. These shapes are dominated by middle values of Cobalt Teal Blue and Permanent Violet Bluish, except the red in the center section—this color is mixed from Quinacridone Rose and a little Green Gold. To apply these shapes and keep their edges sharp, I had to lay each new wash in a dry area; wet washes touching wet shapes would run together. While the houses dried, I glazed the distant hill with a combination of Cobalt Teal Blue and a small amount of Permanent Violet Bluish.

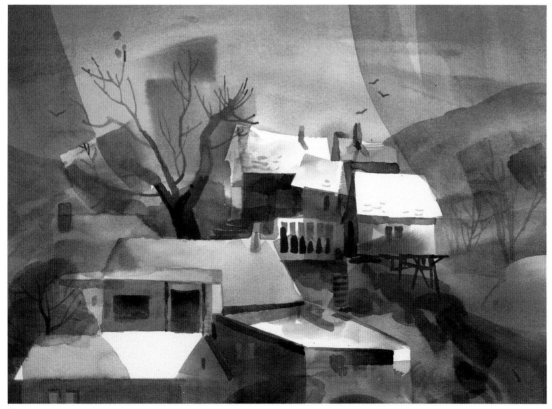

3 To establish the branch structure of the trees, I used a no. 3 rigger filled with varied values of Green Gold and Permanent Violet Bluish. Next, I used a 2-inch soft slant brush and a light wash of Payne's Gray with Cobalt Teal Blue and a small amount of Permanent Violet Bluish to create new neutral shapes to lead the eyes into the composition. I also used this wash to reduce the volume of white and to indicate shadows. The high-chroma colors were muted a little where this glaze covered the original hues, creating contrast in value and intensity.

Happy Hill
Lana 300 lb. cold-pressed,
11″ × 15″ (28cm × 38cm)

Sepia *Winsor & Newton*

This dark brown, almost gray, earth color is a strong stainer (although in most other brands Sepia is not). Its neutrality makes it an excellent color to reduce the intensity of high-chroma colors, particularly that of warm hues. Its color is most attractive when used in very light washes.

Considering its staining nature, Sepia serves as an ideal texturing color under light transparent glazes (for example, wood grain, gravel or submerged pebbles).

◆ **Characteristics**
- Opaque
- Permanent
- Sedimentary
- Staining

❖ **Colors with reasonably similar characteristics**
Sepias of most other brands (Daniel Smith, Holbein, Rembrant, Maimeriblu), Daniel Smith and Holbein Vandyke Brown, Rembrant Neutral Tint, Winsor & Newton Warm Sepia

■ **Complementary color**
Green

▲ **Watch out for . . .**
Because this Sepia is almost black, its complementary color can vary from brand to brand.

PALETTE

Sepia
Winsor & Newton

Quinacridone Rose
Rembrant

Permanent Green Yellowish
Maimeriblu

French Ultramarine
Winsor & Newton

Blockx Green
Blockx

REFERENCE PHOTO

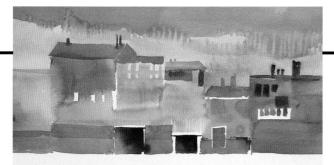 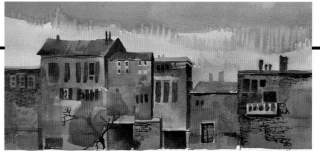

1 I painted the sky with Quinacridone Rose and Blockx Green in a 2-inch soft slant brush. Below this I added Permanent Green Yellowish and reduced the Blockx Green. Where these shapes met, I painted repetitive back runs to avoid a sharp dividing edge. I painted the houses using all my palette colors with varied, strongly charged dominance, leaving some white negative shapes for windows, balconies and doorframes.

2 Next, with pure Sepia in a no. 3 rigger, I added the dark details to the old walls. I also painted the translucent shape of the yellow tree and its supporting trunk, limbs and branches. Most of these small shapes were enhanced by the dark value of Sepia. For example, the roofs and chimneys of the shortest house and the one on its left are painted with a single tone. The chimneys and the stone textures are a dark Sepia.

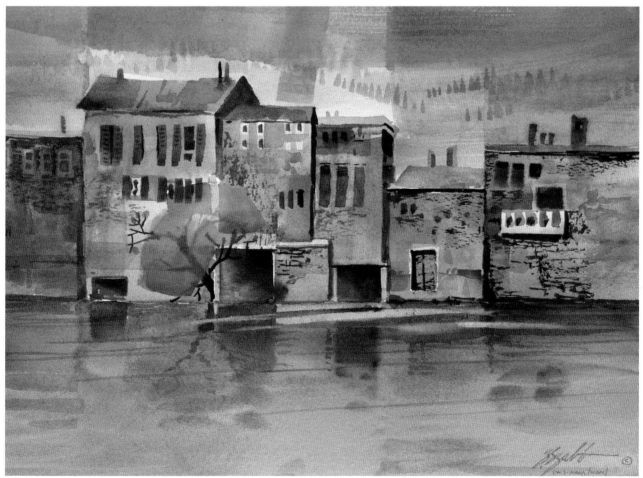

3 Due to the dominant horizontals, I added light vertical glazes to the sky, extending the vertical building walls with a 1½-inch soft slant brush. When dry, I dropped in trees, suggesting distant hills. I painted the water with sky colors. While wet, I added the reflection of the tree and boathouses with a ¾-inch aquarelle brush filled with Sepia and the wall color. When dry, I lifted out the light waves in the center. I added the long horizontal lines to the surface of the water with a no. 3 rigger.

Bright Little Dancer
Lana 300 lb. cold-pressed,
11" × 15" (28cm × 38cm)

Neutral Tint *Blockx*

A meek bluish gray with low intensity and medium tonal value, Neutral Tint is useful to tone down high-chroma colors. It glazes well and behaves like a gentler, lightly staining Payne's Gray.

Practical applications of this color are similar to those of Indigo and Payne's Gray.

◆ Characteristics
- Lightly staining
- Permanent
- Semitransparent

❖ Colors with reasonably similar characteristics
Payne's Gray and Neutral Tint of most other brands (Daniel Smith, Holbein, Maimeriblu, Rembrant, Winsor & Newton), Indigo (Daniel Smith, Holbein, Maimeriblu, Rembrant, Winsor & Newton)

■ Complementary color
Yellow orange

▲ Watch out for . . .
Neutral Tint is a cool darkening agent of limited use. Depending on this color too much can become a crutch for an artist, robbing his or her paintings of glowing, high-chroma colors.

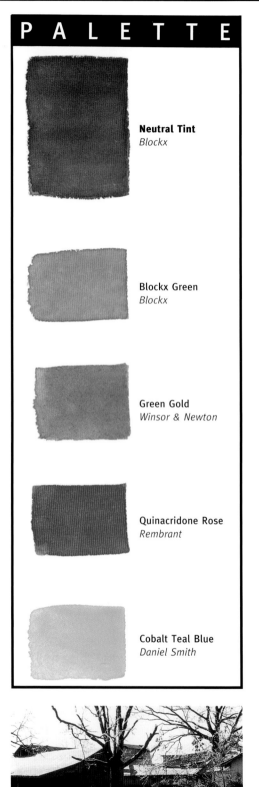

PALETTE

Neutral Tint
Blockx

Blockx Green
Blockx

Green Gold
Winsor & Newton

Quinacridone Rose
Rembrant

Cobalt Teal Blue
Daniel Smith

REFERENCE PHOTO

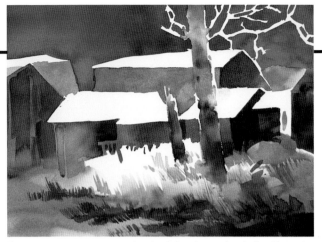

1 The "shy" nature of my key color allowed me to apply the dark sky wash with Neutral Tint, Blockx Green and a little Quinacridone Rose, with the Blockx Green as the dominant hue. I used my maneuverable ¾-inch aquarelle brush and painted around the tree silhouette and the top of the roof, leaving their white negative shapes exposed in high contrast. I treated the shaded portions of the buildings and the foreground the same way, but my color was dominated by Quin-acridone Rose.

2 After the previous colors dried, I defined some basic details on the buildings with a second, darker glaze in a similar manner. Still using the same brush, I dropped in a charged wash for the tree and stump in the foreground. To shade the bed of weeds under the tree, I painted a few angular clusters with Cobalt Teal Blue and diluted Green Gold next to each other. As a foreground texture, I painted the dark grass using a 2-inch slant bristle brush filled with very dark color and very little water.

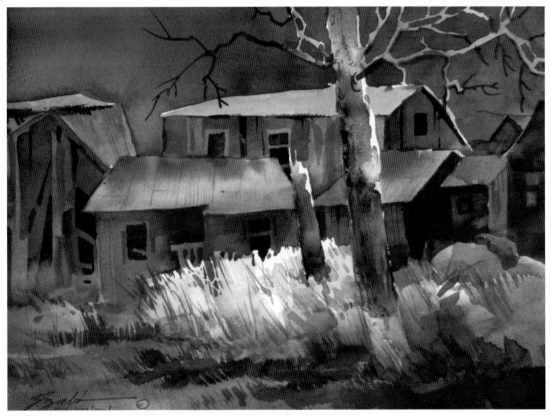

3 I continued with light glazes for the roofs. I wet each shape and applied the rusty colors with a 1½-inch soft slant brush, and then charged them with Cobalt Teal Blue. I also glazed darker washes in the foreground until only the tall weeds and the edges of the tree showed white. I added diluted Green Gold to these weeds to liven up the contrasting bright spot. With a no. 3 rigger, I painted the breaks in the walls and the windows and doors using a dark Neutral Tint mixed with Blockx Green. I completed the watercolor by toning down the white negative branches and painting a few additional dark positive ones.

The Broken Past
Lana 300 lb. cold-pressed,
11" × 15" (28cm × 38cm)

Ivory Black *Blockx*

A gentle black that actually leans more to gray, Ivory Black makes beautiful light-gray washes. Because of its nondominant nature, when mixed in small quantity it can reduce the intensity of bright colors without changing the integrity of their hue. When mixed with yellows, the wash results in mellow greens. Like all neutral darks, it performs best when applied in light tones, although it is capable of holding its own as a rich black.

Ivory Black is a good color to use in angry storm clouds, in neutral shadows, in snow shadows, rocks, tree trunks and similar applications.

◆ **Characteristics**
- Nonstaining
- Opaque
- Permanent
- Sedimentary

❖ **Colors with reasonably similar characteristics**
Daniel Smith Graphite Gray, Holbein Peach Black, Winsor & Newton Charcoal Gray, Ivory Black of Maimeriblu, Daniel Smith, Holbein, Winsor & Newton

■ **Complementary color**
None

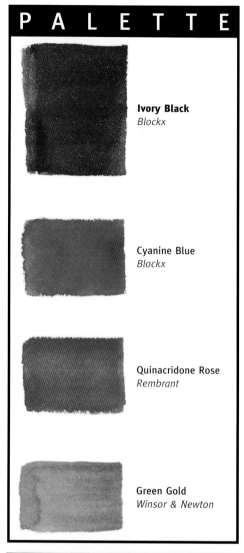

P A L E T T E

Ivory Black
Blockx

Cyanine Blue
Blockx

Quinacridone Rose
Rembrant

Green Gold
Winsor & Newton

REFERENCE PHOTO

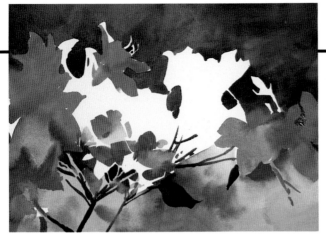

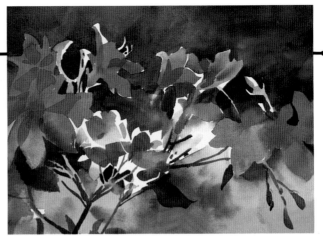

1 I began on a dry surface, slanting the paper so my wash beaded on the bottom edge. I now had the time to go around the contour of the negative shape. Protecting the silhouette of the flowers, I painted the top half of my background using a 1-inch aquarelle brush and a mix of all the palette colors, dominated by Ivory Black but always influenced by varied color charges. At the bottom of the cluster, I allowed the colors to dominate and the Ivory Black to be subordinate. Next I painted the shaded flowers using Quinacridone Rose and Cyanine Blue. For the stems and leaves, I added Ivory Black.

2 I switched to a ¾-inch aquarelle brush and continued with details on the flowers. Where two petals overlapped, I defined the darker shapes by using the same colors but doubling the value. I also introduced the warming influence of the Green Gold.

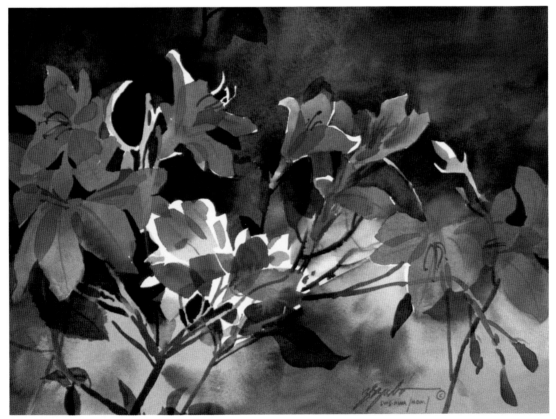

3 From here on I concentrated on calligraphy. With a no. 3 rigger, I added the final stems, the stamens and the veins in the flower petals. I also increased the influence of Green Gold to give a boost to the illusion of warm light coming from the back. The surviving white is concentrated where the subtle center of interest is located. To give this area even more importance, I increased the value of the nearby background with Ivory Black. The neutrality of Ivory Black and the clarity of the other colors, combined with the carefully protected white, created the desired sparkle in this watercolor.

Choir Practice
Lana 300 lb. cold-pressed,
11" × 15" (28cm × 38cm)

White Giant
Lana 300 lb. cold-pressed,
15″ × 20″ (38cm × 51cm)

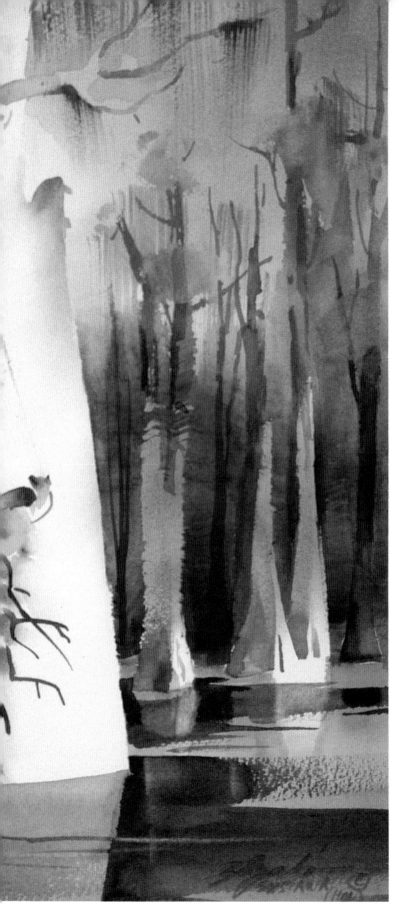

Color Systems That Work

One of the most common problems of a water-colorist in the early years is that he is color happy. More color is simply more — not better. I want to introduce you to a few commonly used systems that work much better than the color chaos caused by the use of an unnecessary excess of colors. You may learn that it pays to be disciplined and to choose the minimum number of colors for maximum aesthetic result.

> **"** *An artist's working life is marked by intensive application and intense discipline.*"
>
> —John F. Kennedy (1917-1963)

The Color Systems Dial

A color wheel is a great tool for choosing successful color schemes. My Color Systems Dial not only allows you to identify the major color schemes, such as split complementary and triadic, it also shows each color mixed with a warm neutral, with a cool neutral and with its complement in various degrees of dominance, allowing you to choose different values of the color you're using without having to mix the colors yourself. Allow a small margin of error for the exactness of the mixed hues caused by deviation between the printed and painted colors, and variation of colors among brands.

I painted this dial with my favorite brand, Maimeriblu artist-quality transparent watercolors.

Making the Color Systems Dial

To assemble the dial, photocopy the overlay on page 113 at 100 percent. Cut around the circle on the photocopy, then cut out the eight shaded blocks with a craft knife. Line up the black dot in the center of the overlay with the dot in the center of the color dial on page 115.

If you wish to attach the overlay to the color dial, many print shops can make an inexpensive and accurate color photocopy of the dial on page 115. Attach the overlay to the color photocopy with a round paper fastener.

A high-quality version of this dial is also available. Write to the address listed in the front of the book for more information.

Color Systems Dial Overlay

Using the Color Systems Dial

Hue

The primary, secondary and tertiary hues are shown on the outer circle of the color dial. Line up the pie-shaped window on the overlay with the key color you intend to analyze.

Analogous Colors

On either side of the key color, the two most closely related analogous colors are identified.

Complementary Color

The color directly opposite the key color is its complementary color.

Split Complementaries

On either side of the complementary color are the key color's two split complementaries.

Triadic

Along with the key color, the two colors on the outside of the split complementaries form the triadic colors.

Tint

The two swatches in the pie-shaped window directly below the key color will show its tint in 50 percent (on the left) and 75 percent strength (on the right).

Key Color/Complement Mix

A fifty-fifty mix of the key color with its complementary is shown directly below the tints.

Dominant Key Color/Dominant Complement Mixes

Two swatches appear below the Key Color/Complement mix. The one on the left represents the key color in a dominant 60 percent strength and its complementary in 40 percent tonal value. The color on the right in the same window shows the colors mixed with the complementary at 60 percent dominance and the key color at 40 percent tonal value.

Key Color/Cool Neutral Mix

The next swatch down shows a fifty-fifty combination of the key color mixed with Payne's Gray (a cool neutral color).

Key Color/Warm Neutral Mix

The last swatch in the pie-shaped window shows the key color mixed with Sepia (a warm neutral color) in a fifty-fifty combination.

Simply turning the overlay dial to any other key color exposes its system in a similar manner.

Color Systems Dial

Analogous Color Dominance

Analogous hues are next to or very close to each other on the spectral color wheel. They are harmonious and cooperative colors, indicating calm harmony when they dominate a composition. Complementary color accents add excitement to analogous compositions, as long as they don't dominate them. Variation in the nature of the selected analogous colors is not as essential as in complementary systems.

Demonstration 1

PALETTE

French Ultramarine
Winsor & Newton

Cobalt Teal Blue
Daniel Smith

Cadmium Green
Holbein

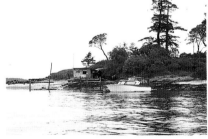

REFERENCE PHOTO

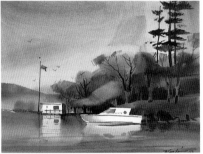

1 I started on dry paper, using a 2-inch soft slant brush. I applied the light washes for the sky area, using all three colors in a very wet condition. I did not mix the colors into an even tone, but let each hue blend with varied dominance. I switched to a 1½-inch slant bristle brush and painted the basis of the darker ground shapes, starting on the left edge of the painting. I used French Ultramarine and Cobalt Teal Blue in a medium-dark strength. On the right center, I used the colors a little darker and charged the unified wet washes with single colors, encouraging each of them to show its own color as they blended. I made sure that the sharp top edges of the boat and the boathouse were started to define their negative shapes. Then I proceeded with the water. I used the same colors but much less Cadmium Green and even less French Ultramarine. This wash completed the bottom half of the white silhouettes.

2 I switched to a ¾-inch aquarelle brush and blocked in the windows on the boat and on the distant structure. Turning to a no. 3 rigger, I painted the small branches and the dark spaces between the light tree trunks, the tall pine trunks and the flag. Where the calligraphic branches showed through the luminous lighter green foliage, I painted Cadmium Green-dominated lines. At other locations, the lines were dominated by French Ultramarine mixed with Cadmium Green as a subordinate color. Then I added color and a little more value to the water and showed some details relating to the images above.

Cool
Lana 300 lb. cold-pressed, 11″×15″ (28cm×38cm)
Collection of Margaret Lister.

Demonstration 2

1 Using a 2-inch soft slant brush and all three colors on my palette in light values, I painted the sky quickly and defined the negative rim of the mountains. I animated the wet shape by varying the color dominance and by painting the light rhythmical light lines with a little clear water in a no. 3 rigger. I went back to my 2-inch soft slant brush and, using the same colors in varied dominance, glazed the shaded crevasses of the mountains. I used Magenta as my darkest value, while the other colors in midvalue supplied variety.

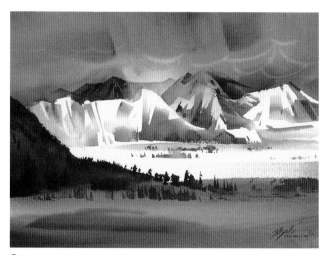

2 I noticed a light shape in the sky resembling a light shaft. To make it stronger, I painted another range of mountains through it and darkened it considerably on the left side of the rays. Switching to a 2-inch slant bristle brush, I used a very rich combination of all three colors, dominated by Magenta, to paint the mountain slope and the flatter foreground. While the wash was still moist, I painted rows of small evergreens to suggest scale. I reduced the massive strength of the white plateau with rapidly dragged light horizontal brushstrokes. I used a ¾-inch aquarelle brush for this, as well as for the tiny tree clusters. The strength of the watercolor is carried by the warm color unity and the impressive contrast of the rich white shapes.

Hot Mountains
Lana 300 lb. cold-pressed, 11″ × 15″ (28cm × 38cm)
Collection of Willa McNeill.

PALETTE

Magenta
Blockx

Quinacridone Rose
Rembrant

Cadmium Red Orange
Blockx

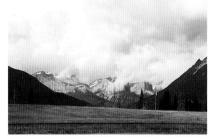

REFERENCE PHOTO

Complementary Dominance

A color's complement is located opposite the color in question on the spectral color wheel—consequently, cool colors are complements to warm colors and vice versa. When two complementary colors are mixed in optically equal volume, the two hues neutralize each other—neither can be identified by looking at the combined wash. When only pure transparent colors are involved, the wash is clean and luminous regardless of the colors' proportionate distribution. If one or both of the mixed colors are opaque, muddy, lifeless colors may result, particularly in thick consistency.

PALETTE

Cadmium Yellow Lemon
Rembrant

Permanent Violet Bluish
Maimeriblu

Demonstration 1

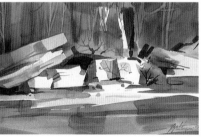

1 I painted the medium-dark shape of the background on a dry surface with both colors. I dominated the largest portion with Permanent Violet Bluish, but the yellow took command of the shape of the future shrub in the center. I left out two vertical negative shapes as the beginning of contrasting trees. When the wash had just lost its shine, I rapidly drew light lines into the damp color with a no. 3 rigger: These lines resemble light trees. Immediately after this, with the same little brush filled with very dark Permanent Violet Bluish, I painted the slim, dark trees in a similar manner.

2 I continued with two glazes: With the first and lighter tone, I defined the white negative shapes of the rocks and that of the foreground. After this dried, I painted the darker bold shapes, giving the rocks and the foreground more depth. To echo the orangy shrub, I added more yellow shapes gently mixed with violet, as well as Cadmium Yellow Lemon by itself. Using the little rigger again, I indicated a few dark cracks in the rocks, as well as the branches of the shrubs. The strength of the white shapes with sharp edges next to the strong darks contributed to the drama of this very simply painted watercolor.

Rough Diamonds
Lana 300 lb. cold-pressed, 11″ × 15″ (28cm × 38cm)

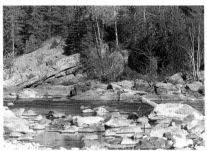

REFERENCE PHOTO

Demonstration 2

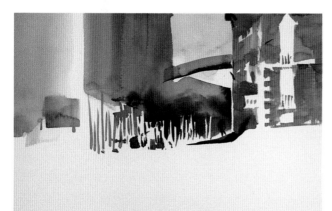

1 I started by defining the two buildings, with the warm Scarlet Lake dominating one wall and the cool Blockx Green on the other one. I darkened the wet, cool shape around the negative white gondola posts with Scarlet Lake, and mixed Blockx Green and Scarlet Lake in equal volume for the brownish tone on the right side. I let the green dominate the dark shape of the window on the left side, the shape of the bridge between the two structures and the dark gondola touching the red wall.

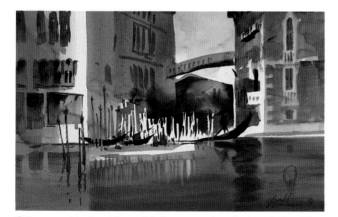

Sleepy Gondolas
Lana 300 lb. cold-
pressed, 11″×15″
(28cm×38cm)

2 Because this sketch is a quick demonstration of color relationships, I suggested the details rather than refining them. Using a ¾-inch aquarelle brush, I indicated the remaining windows on the left building and the decorative dents on the bridge in two values of both colors mixed equally. After these shapes dried, I glazed an oblique cast shadow over the outside edge with a 2-inch soft slant brush. I painted the water with both colors in a rich mix with Blockx Green dominant, leaving white paper directly below the gondolas. Next I painted the reflection of the red wall and the large gondola in front of it into the damp paper with a red dominated mix using a ¾-inch aquarelle brush. With a no. 3 rigger and clean water, I dropped in the reflections of the white posts. I followed this by painting the dark reflections of the windows and posts against the base of the white wall—and the sketch was completed.

PALETTE

Scarlet Lake
Holbein

Blockx Green
Blockx

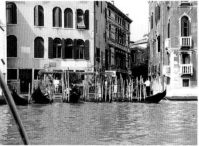

REFERENCE PHOTO

Triadic Combinations

Triadic colors are any three colors that are equal distances apart on each side on the spectral color wheel. They neutralize each other when mixed in optically equal combinations. If one of the three colors is stronger than either of the other two, its hue will dominate the others. Any of the individual colors can excite a wet triadic wash when it is used as a charging color. The key word with triads is *balance*.

Demonstration 1

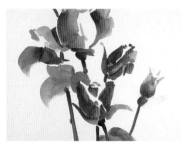

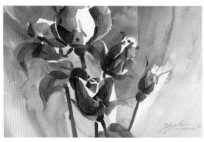

1 I began on a dry surface with a 1-inch aquarelle brush. I painted the shapes of the roses, starting with the largest one at the top and working down to the smallest bud at the right. As I painted the flowers, I started with Quinacridone Magenta and charged each section with Winsor Yellow Deep and/or Cobalt Teal Blue while the color was still wet. For the basic color of the leaves, I used Cobalt Teal Blue and added the red or yellow complement into the wet wash. Next I applied the dark stems with a no. 3 rigger and a dark color mixed from all three pigments. Analyzing the shapes, I decided that the only thing missing was a background.

2 Although the leftover white was overwhelming, it offered the opportunity to add a design because it supplied the necessary light to make any color glow. Although I used all three colors in medium value, I concentrated on the dominant combination of Cobalt Teal Blue and Quinacridone Magenta accented with a little Winsor Yellow Deep. I created a repetition of curvilinear shapes relating to the cuplike forms of the roses: I let the washes ooze and flow freely. The negative white shapes on the roses united their forms and made the background subordinate by comparison.

Happy Times
Lana 300 lb. cold-pressed, 11" × 15" (28cm × 38cm)

REFERENCE PHOTO

Demonstration 2

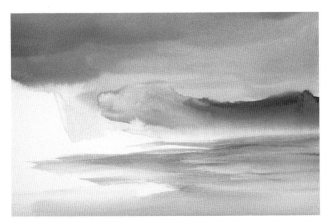

1 I wet the top half of the paper and used a 1-inch aquarelle brush to start painting the sky, using all three colors. At the top left, the Winsor Blue and Winsor Red were stronger; on the right side, the Cadmium Green dominated. I followed with the bluish mountain at the right center, leaving the top edge relatively sharp and losing the bottom. I continued with the sandy beach—the color was the result of Cadmium Green and Winsor Blue brushed on horizontally. I also glazed on the shape of the blue water, indicating low tide.

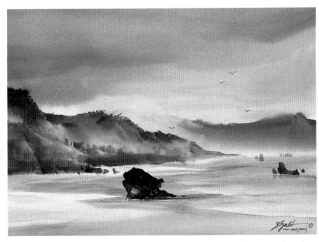

2 Now I was ready to paint the closer point of land. I started with a Cadmium Green base wash with a 2-inch slant bristle brush. I darkened the top edges with Winsor Blue and the bottom edge with a Winsor Red-dominated color, defining the contrasting junction between the sand and the mountain. For the angular rock in the sand, I applied all three colors in heavy consistency. After I knifed a little texture, the individual hues glowed. I sprinkled the more distant protruding rock shapes paler and smaller to make them recede. The rock in the midground is on the edge of the water, and with its reflection I finished the composition.

Beach Bum
Lana 300 lb. cold-pressed, 11″ × 15″ (28cm × 38cm)
Collection of Meredith and Molly George.

PALETTE

Cadmium Green
Holbein

Winsor Blue (Green Shade)
Winsor & Newton

Winsor Red
Winsor & Newton

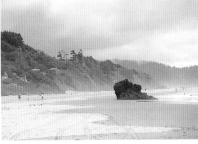

REFERENCE PHOTO

The Role of Isolated Colors

An isolated color creates an irresistible attraction to its location. It is one sure way to strengthen the center of interest. To avoid appearing too forceful, echoes of the color should be repeated in several places throughout the painting. When two complementary colors are equally mixed, the resulting neutral color does not count as an echo because it visually hides both hues. Isolated colors work best when they are applied as subtle accents rather than as loud compositional bullies.

PALETTE

Green Gold
Winsor & Newton

Brown Madder
Winsor & Newton

Permanent Violet Bluish
Maimeriblu

Bluish Green
Rembrant

Demonstration 1

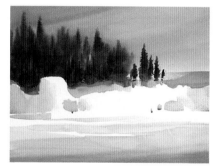

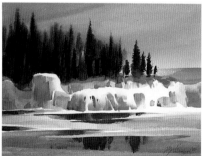

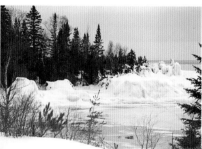

REFERENCE PHOTO

1 With a 2-inch soft slant brush, I applied the Bluish Green part of the sky, which also wet the paper. I charged this wash with Permanent Violet Bluish at the top left, and with Green Gold near the horizon. I switched to a 2-inch slant bristle brush and painted the evergreens with dark colors, changing the dominant color as I went back and forth. Before these colors dried, I charged Gold Green and Brown Madder into the lowest part of the shape. The wet, light color in my brush replaced the darker wash with glowing golden color in the shapes of evergreens. With a ¾-inch aquarelle brush, I mixed Bluish Green, Permanent Violet Bluish and a touch of Brown Madder in very light value, and painted the shimmering water in the distance using a dry-brush technique. I used the same colors to paint around the white ice and for the foreground shading.

2 After everything dried, I painted the dark, sharp details on the trees with the 2-inch slant bristle brush. Switching back to a ¾-inch aquarelle brush, I painted the shapes of the reflecting puddles with a medium-value glaze of Permanent Violet Bluish, Bluish Green and Brown Madder. Into these wet glazes I painted the reflecting dark trees, using the same color combination but in very dark value. In the white shape, I painted the ice with Bluish Green, isolated in its full intensity. Then I added softer complements of Permanent Violet Bluish and a little Green Gold. After everything dried, I brushed a very light glaze of Green Gold onto the foreground snow to relate it to the sky.

Frozen Emerald
Lana 300 lb. cold-pressed, 11″ × 15″ (28cm × 38cm)

Demonstration 2

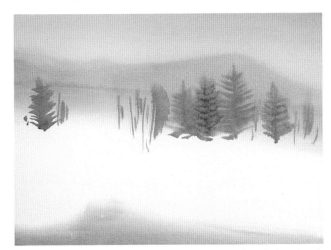

1 I painted the sky on very wet paper using a 2-inch soft slant brush with a light mix of Burnt Sienna and French Ultramarine. Adding a touch of Permanent Violet Bluish, I painted the distant mountain in a slightly darker value, leaving the top edge a little sharper than the bottom to indicate mist. I then repeated the process to fill in the bottom of the paper, this time softening the top edge. Next I added a little Permanent Green Yellowish to my colors and, using a 2-inch slant bristle brush, dropped in the shapes of the evergreens.

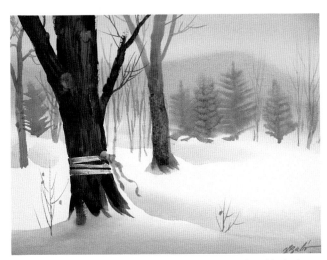

2 I masked out the ribbon shape with tape. I then painted in the large tree with a ¾-inch aquarelle brush, using Burnt Sienna, Permanent Violet Bluish and French Ultramarine in varied dominance. I used lighter values for the paler trees. As the color lost its shine, I dragged the edge of my palette knife over the tree trunk, and a subtle texture emerged. Next I sharpened the edges of the snow with a lost-and-found-edge technique, applying the same mix for the snow as I used previously. With a no. 3 rigger, I painted the small branches, a few distant trees and the twigs in the foreground snow with a few Burnt Sienna leaves. Last, I painted the yellow ribbon with Permanent Green Yellowish and a little Permanent Violet Bluish.

Remembrance
Lana 300 lb. cold-pressed, 11″ × 15″ (28cm × 38cm)

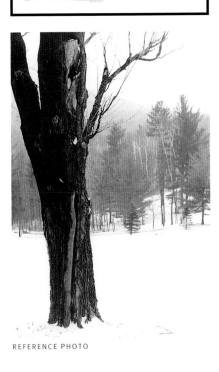

REFERENCE PHOTO

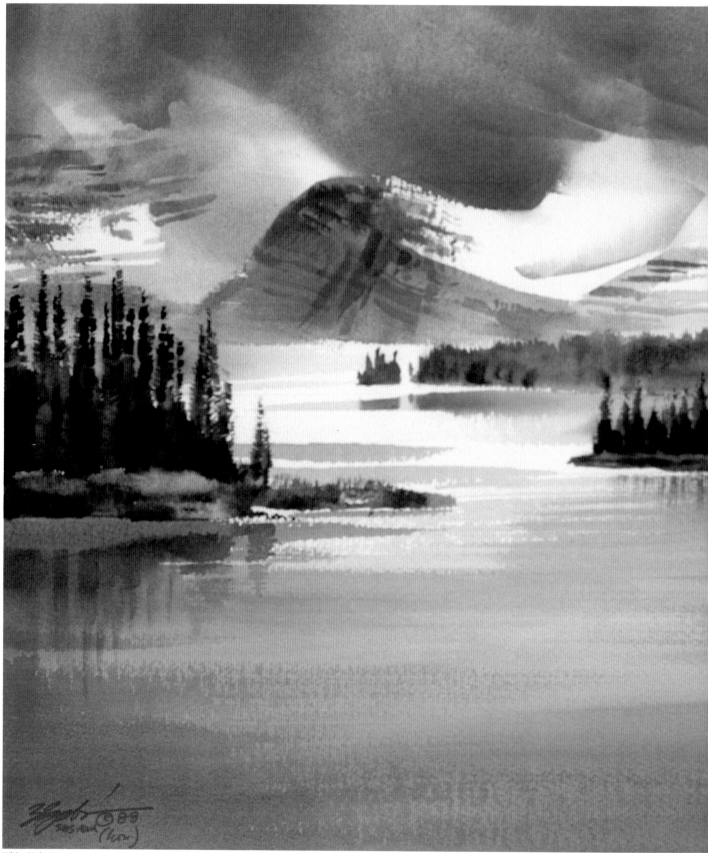

White Majesty
Arches 300 lb. cold-pressed,
15″ × 20″ (38cm × 51cm)

Conclusion

After you have traveled with me through the pages of this book, you are ready to experiment on your own. No matter how much new information you are exposed to, until you apply your new-found knowledge, it is simply theory: This book's information is no exception. Practice and more practice is the only way your work will benefit from what you have learned.

Remember that the proportions in all the mixes in this book are judged by me. Your judgment may differ, but that is precisely what makes watercolor exciting: No two images will ever be exactly the same. Accept the printed color as a close approximation, not as perfection.

Don't try to copy the demonstrations in this book (or anything in nature for that matter) precisely. When you interpret, you add the most precious component to the painting—your own unique nature. Making your own decisions and adding your own feelings is the best way to earn maximum dividends from your invested time.

I hope that you will use the information in this book as a learning tool. Organized colors applied with discipline and knowledge will increase your enjoyment while you paint and substantially improve your communication to your viewers.

Index